100 YEARS OF WOLVERHAMPTON'S AIRPORTS

100 YEARS OF WOLVERHAMPTON'S AIRPORTS

ALEC BREW

AMBERLEY

First published 2009

Amberley Publishing Plc
Cirencester Road, Chalford,
Stroud, Gloucestershire, GL6 8PE

www.amberley-books.com

ISBN 978 1 84868 486 7

British Library Cataloguing in Publication Data.
A catalogue record for this book is available from the
British Library.

Typeset in 10pt on 12pt Sabon.
Typesetting and Origination by FONTHILLDESIGN.
Printed in the UK.

Contents

Acknowledgements

I have acquired photographs from many sources over the years, and in particular I am grateful to Paul Strothers, of Dowty Boulton Paul Ltd (now GE Aviation) for access to the Boulton Paul Aircraft photographic archives; to the late Cyril Harper, for his extensive collection of Halfpenny Green photographs and for information from his own book, *A Personal History of Halfpenny Green Airport*; to the irrepressible enthusiast, Vaughan K. Meers, for his many contributions; to Maurice Marsh, Chris Martin, Dave Welch and the late Keith Sedgewick for their many photographs of Pendeford and Halfpenny Green. Peter Hudson gave permission for the use of the photographs of his late mother gliding at Clive Farm. Others to whom I owe thanks are Colin Penny, the late Jim Boulton, Ken Jones, Roy Targonski, Tony Rowland, and the very patient Wendy Matthiason. If there are any other people who have contributed photographs or help over the years, and I have forgotten to acknowledge them here, I apologise.

Introduction

On 27 June 1910 the first ever all-British flying meeting began at Dunstall Park Racecourse, Wolverhampton, which became the first designated airfield for the town, and began an unbroken century of flying in the area. Dunstall Park, actually one of the first airfields in the whole country, was to remain the town's airfield until after the First World War, though an anti-Zeppelin landing-strip was established at the Fern Fields, Perton during the War.

It was this strip that was used for any local flying during the twenties and early thirties, and during the Second World War an RAF airfield, RAF Perton, was built adjacent to it, on Wrottesley Park. By then Wolverhampton's first true municipal airport had been built at Barnhurst Farm, Pendeford. Though flying had already commenced in 1936, Wolverhampton Airport did not officially open until 27 June 1938, exactly twenty-eight years after Dunstall Park.

The municipal airport was taken over as a training airfield, RAF Wolverhampton, during the war, but resumed its civil function when peace was restored. RAF Perton closed after the war, but remained largely untouched until the huge new housing estate was built on it during the 1970s. A similar fate awaited Pendeford after its closure in 1971.

The overlapping history of Wolverhampton's flying fields continued, the former RAF airfield at Halfpenny Green reopening for civil flying in 1961. Halfpenny Green had been built as an RAF training airfield during the war, and was reopened after its post-war closure in the early 1950s. After lying dormant for seven years, it became Wolverhampton's de facto airfield with the closure of Pendeford, a fact recognised by its subsequent rebranding, firstly as Wolverhampton Business Airport, and now as Wolverhampton Halfpenny Green Airport. On 27 June 2010, Wolverhampton starts its 100th year of having a designated local airfield.

Dunstall Park

On 3 September 1909 a crowded meeting in Birmingham lead to the formation of the Midland Aero Club. During the summer of 1909 Great Britain had suddenly become enthusiastic about aviation. The efforts of S. F. Cody and A. V. Roe were finally being appreciated; the first Channel flight by Louis Bleriot, and news of the flying being undertaken in France and elsewhere, had turned aviation from a thing of ridicule to one of boundless possibilities.

There had been two aviation meetings in Britain during 1909, at Blackpool and at Doncaster, both dominated by French aviators, so that when, in March 1910, the new aero club were offered the use of Dunstall Park Racecourse as its new flying field, they decided to promote an all-British flying meeting, offering generous prizes for various achievements, such as the aggregate time in the air during the week, and the shortest take-off run.

Entry to the meeting was to be restricted to British nationals who held an Aviator's Certificate (Pilot's Licence). At the start of the meeting only sixteen British Aviator's Certificates had been issued, and eleven of those pilots were to fly at the meeting, plus some others who held French certificates. The club erected six wooden hangars in a row on the canal side of the racecourse, and aircraft began to arrive before the meeting, their owners anxious to gain their Aviator's Certificates so that they might take part. Flying thus began before the first day of the meeting, which was on 27 June, though much of this flying was very brief; in some cases the aircraft being used was being test-flown for the first time, while its pilot/designer was also teaching himself to fly!

Though dogged by bad weather, the flying meeting, only the third ever held in the country, attracted huge crowds and considerable press interest. After the meeting most of the flyers left, heading for the next meeting at Bournemouth, but some aircraft remained. Dunstall Park continued to be used to test-fly the odd aircraft, most notably those built by the two local car companies, Sunbeam and Star, but also what was for a time the largest aircraft in the world, the Seddon Mayfly. When, in 1913, Sunbeam bought a Farman monoplane on which to test their new V8 aero-engine, they engaged a young pilot who was making a name for himself at Brooklands, Jack Alcock. In 1919 he was to become the first pilot to fly the Atlantic non-stop, in a Vickers Vimy. The Sunbeam-Farman was based at Brooklands and took part in many of the air races in 1913 and 1914, proving its reliability, but Alcock also flew up to Dunstall Park in it. On at least one occasion this was to fetch spare parts for the Sunbeam racing car team at Brooklands – the first air cargo movement from a Wolverhampton airport.

There were also further flying demonstrations by the new breed of itinerant airmen, like Benny Hucks, but increasingly the novelty of just seeing flight had to be spiced up with something more. In the case of Hucks, he became famous as the first British pilot

to loop his aircraft, and when Dolly Shepherd came to Dunstall Park, her specialty was to hang from a trapeze bar suspended beneath a gas balloon, before parachuting to the ground.

The pioneer of British airships, E. T. Willows, based his airship at Dunstall Park for a while, and balloon pilots took advantage of the proximity of Wolverhampton Gas Works to inflate their envelopes before setting course for wherever the wind took them.

During the First World War Dunstall Park was used by Sunbeam to test-fly some of the aircraft they built, as well as aircraft powered by their aero-engines, but as Sunbeam began to slip out of the field of aviation during 1919, the use of Dunstall Park as an airfield ended.

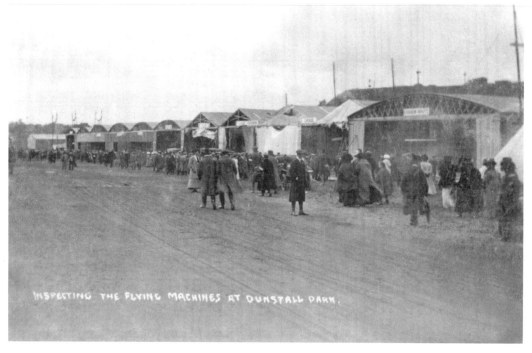

Crowds inspecting the aircraft in their hangars before the flying meeting. The furthest six hangars were erected by the Midland Aero Club as permanent features, the nearer ones were erected just for the flying meeting, the closest one for Claude Grahame-White, and the next for Cecil Grace.

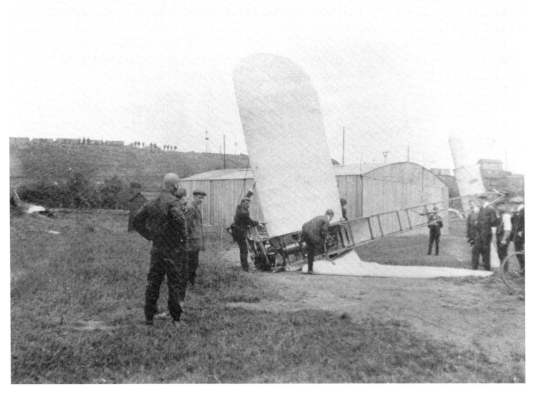

Capt George William Patrick Dawes, on the left, surveying the wreckage of his Humber monoplane in which he stalled and crashed on 17 June while attempting to qualify for his Aviator's Certificate so that he could take part in the meeting. Quite a number of GWR railway workers can be seen watching from Oxley Sidings, one of them probably my grandfather. The aircraft was repaired and Dawes gained Aviator's Certificate no. 17 on 26 July, still at Dunstall Park. He later took the Humber to India, and on 26 March 1911, following engine failure, was forced to land on the Bombay to Baroda railway line. He jumped clear just as a passing goods train smashed the aircraft to splinters. This remarkable man was a veteran of the Boer War, and during the First World War was to command the Royal Flying Corps in the Balkans. In the Second World War he served as a wing commander in the Royal Air Force.

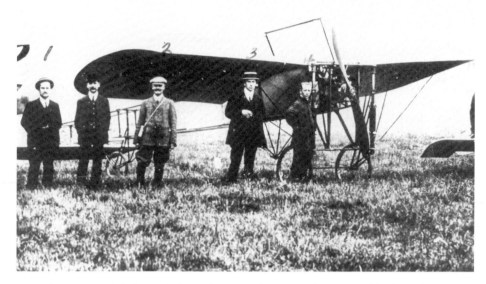

James Radley (no. 4), in front of his Bleriot monoplane, one of two aircraft he brought to Dunstall Park, the other being a Macfie Empress biplane. During the meeting he did little flying in the Macfie, but aggregated 8 minutes, 55 seconds in the Bleriot, the most for a monoplane. Radley later went on to design and fly some of his own aircraft.

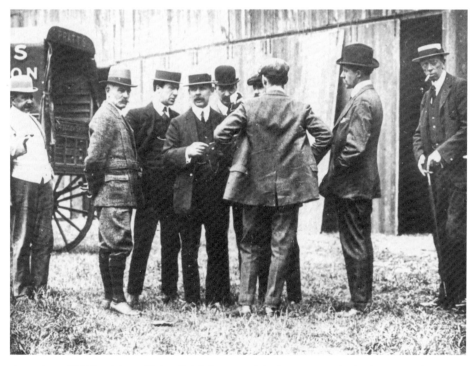

A number of Midland Aero Club officials by one of the hangars, no doubt discussing the appalling weather which prevailed during June 1910.

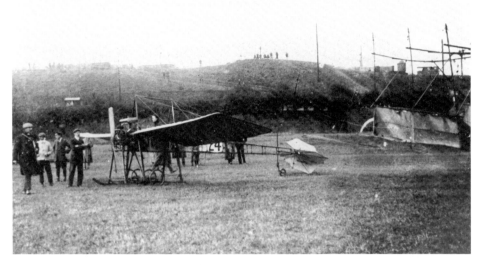

The Howard Wright Avis monoplane of Alan Boyle, with Oxley Sidings (and watching GWR workers) in the background. The Avis was the first successful British monoplane, designed by Howard and Warwick Wright, who were from Tipton. Boyle had only just gained his Aviator's Certificate (no. 13) on 14 June at Brooklands.

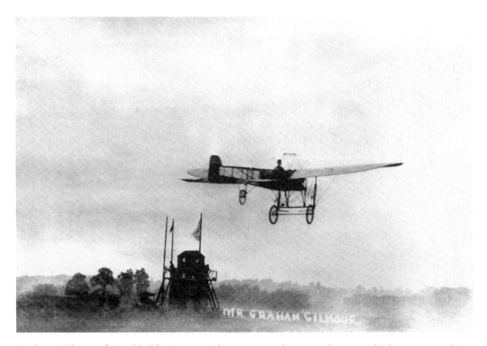

Graham Gilmour flying his Bleriot monoplane near to the control tower, which was erected in the middle of the racecourse. Gilmour held a French Aviator's Certificate, and was to aggregate 7 minutes, 5 seconds flying during the meeting. He was the first Scotsman to fly in public in Scotland, and was to die in a flying accident in 1912.

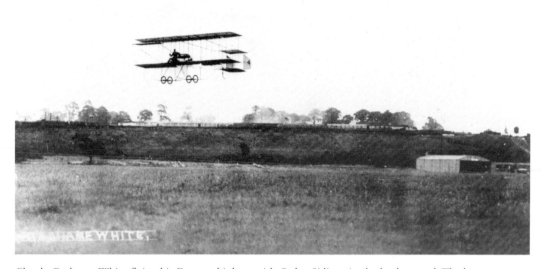

Claude Grahame-White flying his Farman biplane with Oxley Sidings in the background. The large hangar had been erected for the Seddon Mayfly, then under construction in Oldbury, and not to appear at Dunstall Park until after the meeting. Grahame-White won the £1,000 prize for the most aggregate flying during the week with a total of 1 hour, 23 minutes, 20 seconds.

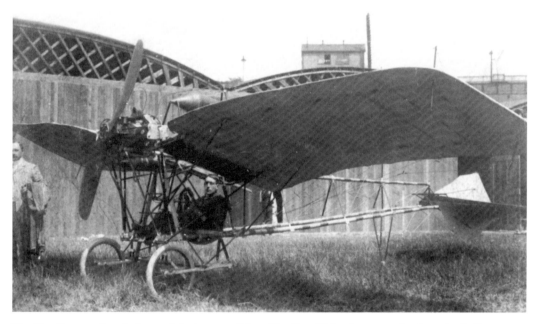

The Hartill monoplane in front of the hangars. Edgar Hartill, a Wolverhampton plumber who built the aircraft, is seated at the controls. Dr Hands of Birmingham, who commissioned it, is standing by the wing-tip. Although it looks a workmanlike representation of a Santos Dumont Demoiselle style aircraft, it failed to fly.

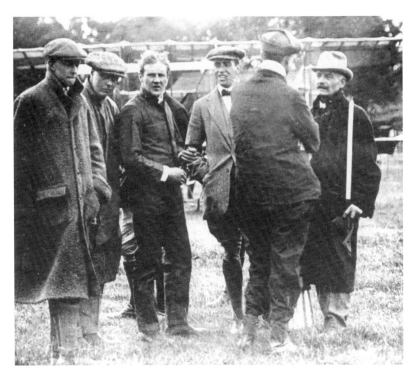

Officials and pilots, including Radley (third left) and Grahame-White (fourth left), in discussion, with one of the Farman biplanes behind. There was huge interest in this flying meeting, reflected by the large crowds that attended and the extensive press coverage.

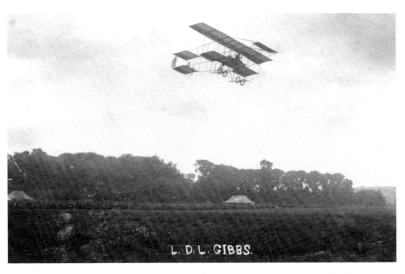

Lt Lancelot Gibbs, RFA, (Aviator's Certificate no. 10), in the air in his Farman biplane, one of two aircraft he had entered for the meeting, the other being a quite similar Sommer biplane. He just failed to beat Grahame-White for the aggregate flying time prize, managing a total of 1 hour, 13 minutes, 5 seconds.

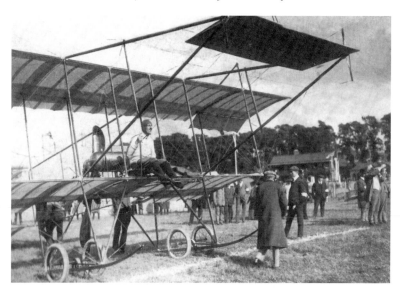

George Cockburn (Aviator's Certificate no. 5) on the white line before winning the 'get off' competition prize of £100, with a take-off run in his Farman biplane of only 100 ft 5 in. Cockburn had been the only Briton to fly during the famous Rheims flying meeting of 1909, and was the second-ever official British pilot, after Moore-Brabazon.

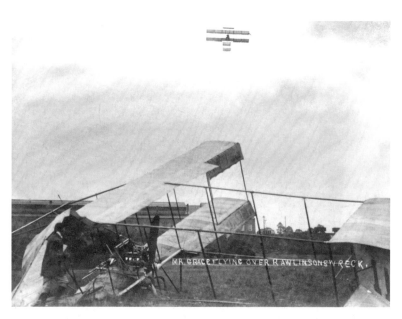

The wreckage of the ENV-engined Farman flown by A. Rawlinson (Aviator's Certificate no. 3), with Cecil Grace (Aviator's Certificate no. 4) flying his Short Biplane overhead. Rawlinson had recently become the first pilot forced down by the actions of another. At the April meeting in Nice, he had been flying his Darracq-powered Farman over the sea when a Russian, named Effimov, flew so close he was forced into the water. Subsequently Rawlinson crashed the same aircraft at Hendon, and proving that disasters come in threes, crashed the rebuilt machine after only seven minutes flying time at Dunstall Park.

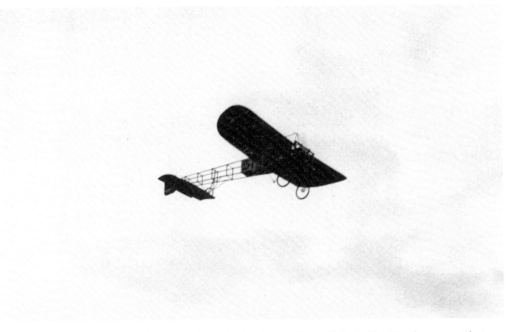

One of the Bleriot or Humber monoplanes in the air over Dunstall Park. The Humber was a Bleriot built under licence by the Humber car company of Coventry.

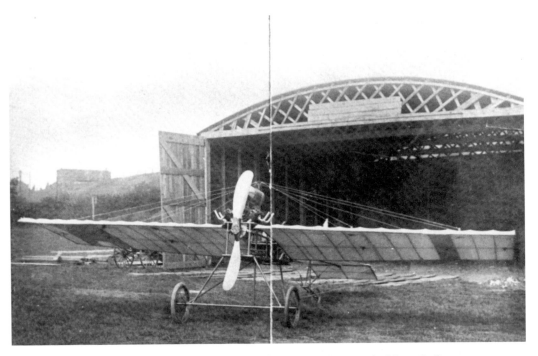

One of the aircraft kept at Dunstall Park after the June meeting was the Mann & Overton monoplane, powered by a 35 hp Anzani engine. It had been built by Mann & Overton of Pimlico, and brought to Dunstall Park for testing. It is shown outside one of the hangars.

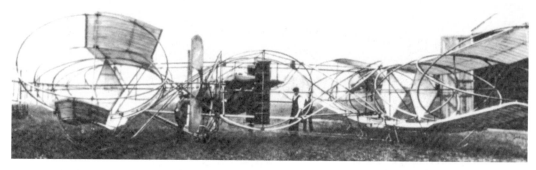

The Seddon Mayfly after erection at Dunstall Park late in 1910. It had been designed by Lt Seddon of the Royal Navy, and built in Oldbury using 2,000 ft of Accles & Pollock steel tubing fashioned into giant hoops. It was powered by two 65 hp New Engine Co. engines, built in Acton, and was the largest aircraft in the world at the time. It was towed through the streets from Oldbury to Wolverhampton but, despite many attempts, failed utterly to fly.

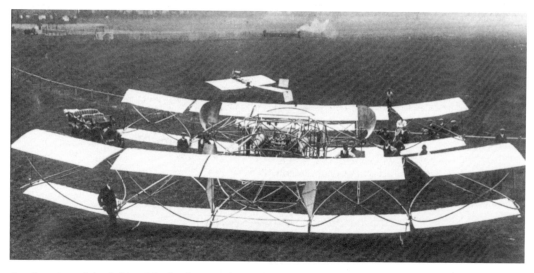

Another view of the Seddon Mayfly showing the tandem biplane wings, and some of the racecourse railings just beyond. In the infield, giving scale, is the Mann & Overton monoplane. Seddon's leave expired and he was recalled to the Navy, his aircraft eventually being broken up.

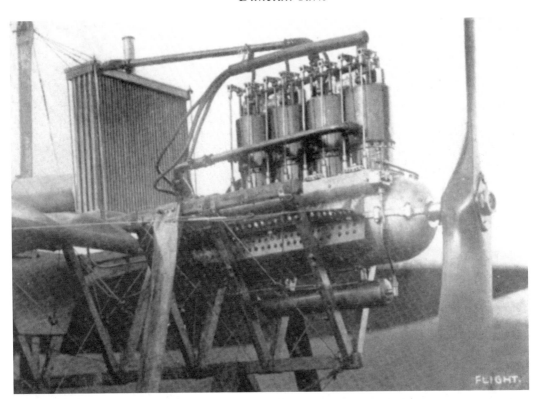

Above and below: The Star Motor Car Company of Wolverhampton was inspired to enter the new world of aviation in 1910. They employed a young Preston man, Granville Eastwood Bradshaw, to design an aircraft, and a 40 hp engine to power it, based on one of their car engines. The Star monoplane appeared before the 1910 meeting but failed to fly. It was heavily modified and flew the following year at Dunstall Park and later at Brooklands. The Star engine was a water-cooled, four-cylinder inline, and still exists in the RAF Museum.

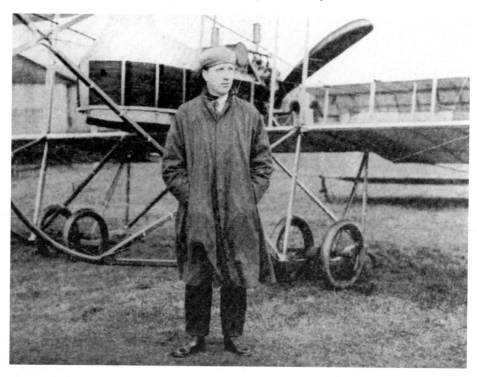

The Sunbeam Motor Car Co. also decided to indulge in the 'Sunrise industry' of aviation, and to test its new 150 hp V8 engine bought a Farman biplane, and engaged a young man called Jack Alcock as its test pilot. Alcock is now forever associated with Arthur Whitten-Brown, and together they were the first men to fly the Atlantic non-stop, but during 1914 he probably flew more than any man in Great Britain in the Sunbeam-Farman shown behind him.

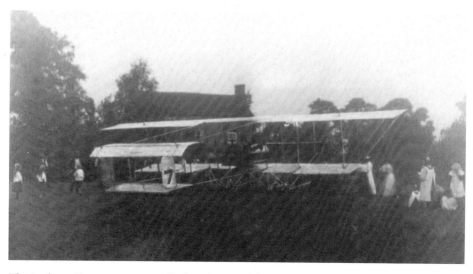

The Sunbeam-Farman was normally based at Brooklands, where it was in the 'shop window', but Alcock did fly it to Dunstall Park, and is shown here on one such journey, over-nighting at Snitterfield, Warwickshire, because of fog.

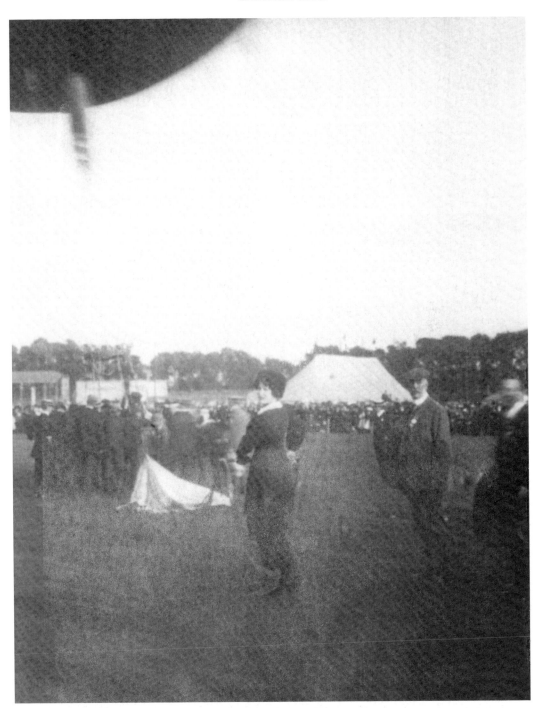

Dolly Shepherd, Britain's first female parachutist, about to ascend at Dunstall Park beneath a gas balloon. The basket of the balloon is hidden by the crowd of men, and her parachute lies on the ground beside them. As she went aloft she was only supported by holding onto the trapeze bar in her hands, with a sling between her legs. She waved to the large crowd as she ascended, and then, at a given moment, the parachute was released and she floated to the ground.

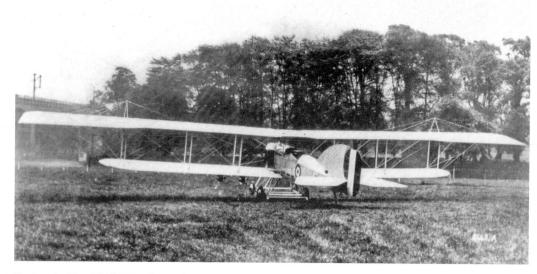

During the First World War the Sunbeam Motor Car Company built nearly 650 aircraft, including fifteen Short Bombers, powered by the 240 hp Sunbeam V12 Ghurkha engine. One at least, shown here, was test-flown at Dunstall Park.

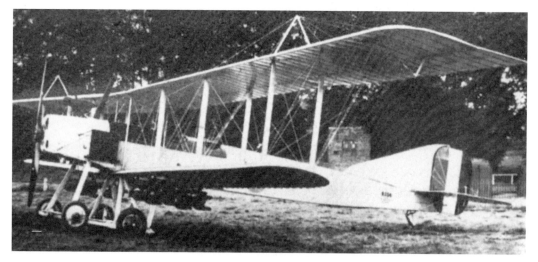

Another view of the Short Bomber at Dunstall Park, showing the bomb-load carried under the wings. The Short Bomber was not a great success as the twin-engined Handley Page O/100 proved far more capable.

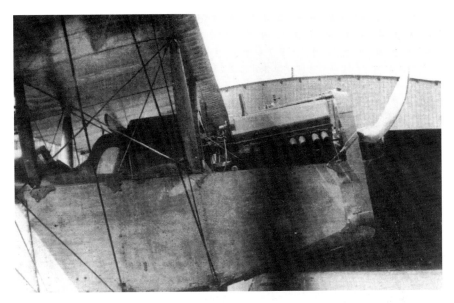

In late 1916 Sunbeam received huge orders, in the thousands, for their new 200 hp V8 Arab engine, off the drawing-board. The first aircraft to which it was fitted was the Martinsyde F.2 fighter, shown here just after the installation at Dunstall Park. The F.2 was not a success and the Arab was removed shortly after, no doubt beginning to exhibit the massive vibration problems that were to beset it and that make it such a failure.

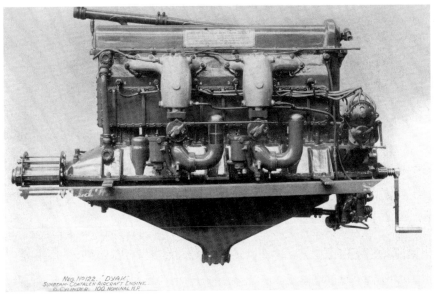

A much better engine than the infamous Arab was the Sunbeam Dyak, a 100 hp six-cylinder inline with an overhead camshaft. Although 160 were ordered near the end of the war, the Armistice resulted in most of them being cancelled. An unusual feature of the engine was a starting handle at the rear, which meant the Dyak could be started from an aircraft's cockpit, without the need for ground assistance in swinging the propeller.

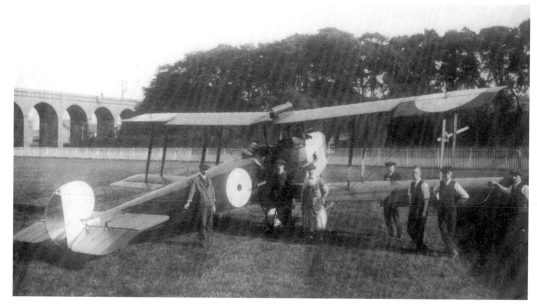

Above and below: Near the end of the war Sunbeam test-flew one of their Dyak water-cooled engines in one of the Avro 504Ks that they built, and test-flew it at Dunstall Park. The six-cylinder water-cooled inline was heavier than the normal rotary engine fitted but proved more reliable. Dyak-powered Avro 504s achieved some success in Australia, and one was the first aircraft operated by QANTAS.

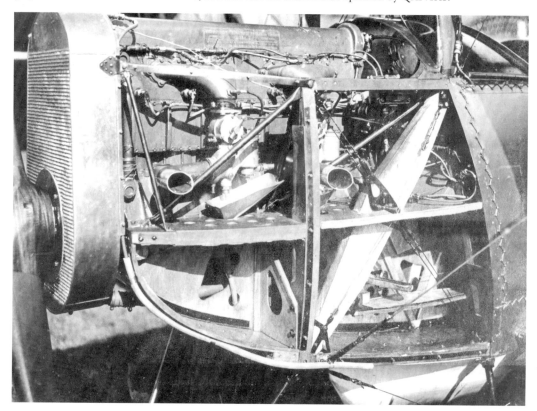

Perton

During the First World War the menace of the Zeppelin loomed large in the fears of the British people. Night raids by the airships bombed Walsall, Tipton and Bilston, though the Zeppelin crews often had no idea exactly where they were, and the damage caused bore no resemblance to the huge costs Germany incurred in building its Zeppelin fleet. Home based squadrons, equipped with the BE.2c and later the FE.2B, struggled to intercept the night raiders.

Part of the strategy adopted was to have a series of relief landing grounds from which the Home Defence Squadrons might operate. One of these was established on the Fern Fields at Perton for the use of No. 38 Squadron, normally based at Castle Bromwich. The amount of flying which took place from Perton during the war was probably quite small, but during the 1920s and early '30s, any aircraft operating from the Wolverhampton area used this Perton strip. This included Alan Cobham's Flying Circus on one occasion. Also, for a short while, a single-seat Henderson-Glenny Gadfly was kept in a shed at the Fern Fields.

During the late 1920s, just a little further along Perton ridge, at Clive Farm, the Midland Glider Club was formed, using the prevailing west winds to bungee launch a Zogling primary glider on what is still known locally as Glider Bank. Later, a BAC VI wheeled glider was acquired and launched by car-towing, almost certainly on the Fern Fields. In 1934 the club moved to the Long Mynd at Church Stretton where the same west-facing advantages were to be found, but with a great deal more height.

During the Second World War an RAF airfield was built adjacent to the Fern Fields, on another part of the Wrottesley Estate. RAF Perton was intended as a fighter field initially, with three runways in a triangular layout, but a quick change of heart lead to it mainly being used as a satellite for the flying training airfields at Tern Hill, Wheaton Aston and Shawbury. The unwanted accommodation units were then taken over and expanded for the use of the Princess Irene Brigade of the Dutch Army. Queen Wilhelmina took up residence in Danescourt, on Perton ridge, and the Dutch gold reserves were kept in the area.

At the end of the war Perton closed and lay dormant, with the former Dutch camp being used to house displaced persons for a while. Despite some attempts to reopen it for civil flying after the municipal airport at Pendeford was closed, Perton was eventually submerged under a tide of brick as the huge new housing estate was constructed. The control tower was refurbished as a temporary community centre for a while, but after it was demolished, the only sign that there was once an airfield at Perton is now the RAF memorial near Sainsbury's supermarket.

Left: Charles Henry (Harry) Nott, on the right, was an observer with No. 38 Squadron. He had won the DCM in France after shooting down two attacking German aircraft as gunner in a No. 15 Squadron BE.2c despite suffering severe injuries, including losing his right eye. Before the war he had been an engine fitter with the Sunbeam Motor Car Co. in Wolverhampton. It is tempting to think he must have flown to Perton, which was within walking distance of his home in Albrighton.

Below: A Vickers FB.5 Gun-bus, photographed by Harry Nott, possibly at Castle Bromwich, where No. 38 Squadron was based. There are no surviving records of just which aircraft might have used Perton during the war.

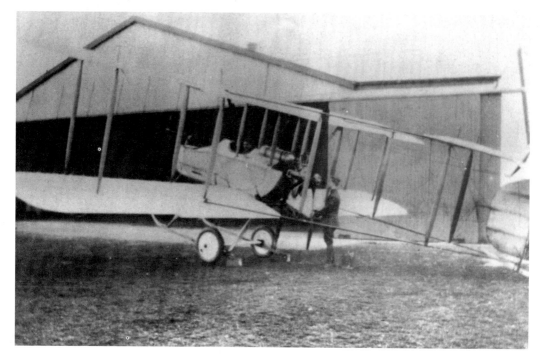

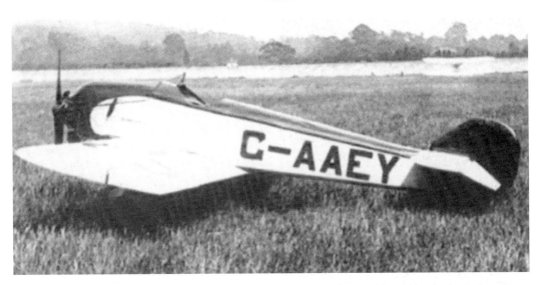

The Henderson-Glenny Gadfly II, G-AAEY, which was privately owned and based in a shed on the Fern Fields in the early 1930s. This was the first of three Gadflies and is shown at Brooklands, where it was made.

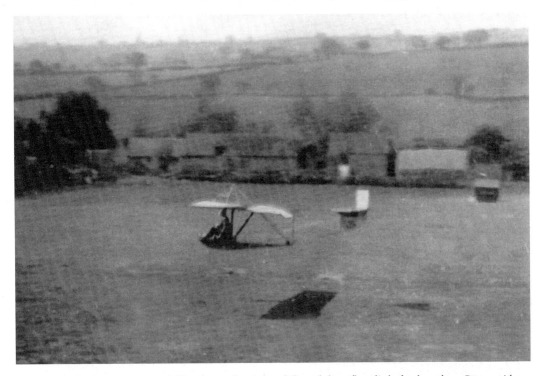

In the late 1920s a group of local men formed a gliding club to fly a little further along Perton ridge from the Fern Fields, at Clive Farm. They acquired a German Zogling Primary glider in kit form, built it themselves, and were launched from the ridge with a bungee rope, skimming down to a landing in the fields below. The Midland Glider Club, as it was then known, was registered at 17 Victoria Street, Wolverhampton.

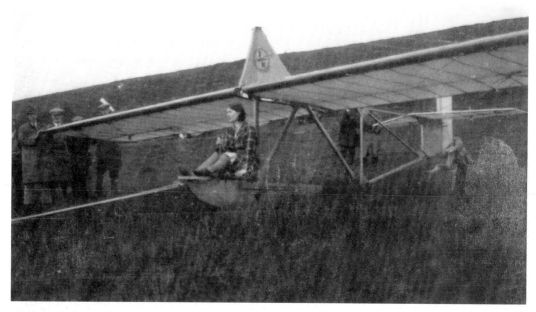

The Zogling is shown ready to be launched with Nellie Gill, daughter of the local pork-pie and sausage maker, F. A. Gill, at the controls. She married another of the glider club members, William Hudson, and lived to the ripe old age of 101. A helper holds the tail, as others hold the wing-tips level, while further members stretch the elastic rope. Once the bungee was fully stretched the wings and tail would be released and the Zogling would shoot forward and into the air.

The full name of the glider was the Stamer Lippisch Zogling, designed in 1926 by Alexander Lippisch, later to become famous as the designer of the Second World War rocket fighter, the Me.163B. Club members can be seen readying it for flight. Glider Bank, as it is still known, was chosen as it faced into the prevailing wind.

The Zogling was replaced in the early 1930s by a BAC VI glider, shown here, equipped with wheels so that it could be towed into the air by a car. The type was later to be produced with a small engine, to become the BAC Drone. The British Aircraft Company had been formed by Charles Lowe-Wild, who was convinced that there was no need for British glider pilots to keep going to Germany for their equipment, and set about successfully creating home-grown designs.

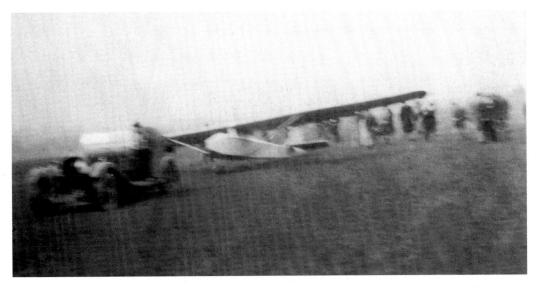

The car is shown here ready to go, on a large flat field, which is almost certainly Fern Fields rather than Clive Farm, as the combination would have needed plenty of room to gain speed. If so, this is one of the few surviving photographs of flying at this airfield.

Members for the club watch as the BAC VI gains speed behind the car, remarkably close behind the car. It is hard to see how such a short tow-rope would have allowed it to be launched into the air, but there is another, very poor-quality photograph showing the glider high above, so it was both launched and able to gain height.

The RAF Perton maintenance team alongside the solitary Bellman hangar, which was behind the control tower near to Wrottesley Park Road. Only minor work was carried out at Perton, major inspections and repairs were undertaken at the parent station, Shawbury, Tern Hill or Wheaton Aston at different times.

The first aircraft ever to land at RAF Perton was a Miles Magister, like this one, although it was damaged, as there was still rubble on the runway it used.

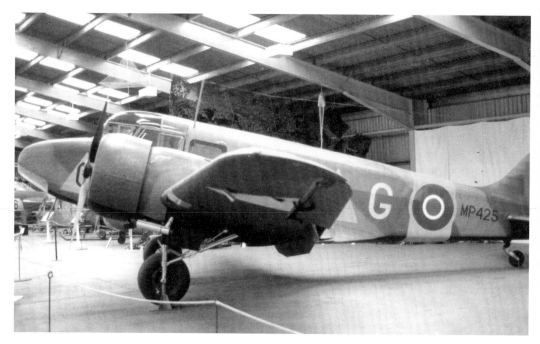

The aircraft most seen in the skies above RAF Perton, when it was a satellite of both RAF Shawbury and RAF Wheaton Aston, was the Airspeed Oxford trainer. This is the RAF Museum's example, MP425, when on display at the Newark Air Museum.

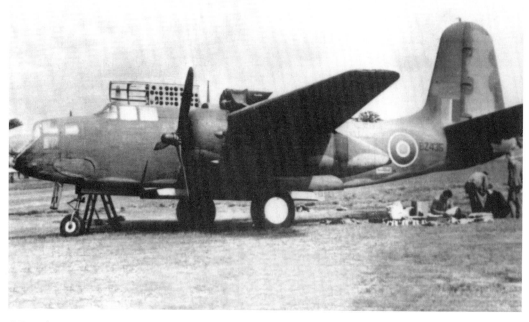

A Douglas Boston, BZ435, at RAF Perton for modification work. Boulton Paul Aircraft at Pendeford undertook modification work on Douglas Bostons, but they were not suitable for Pendeford's short grass runways, so they used nearby Perton.

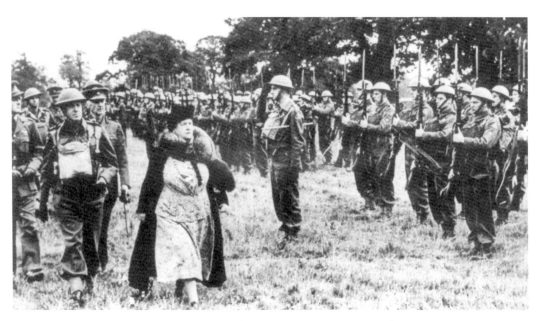

Queen Wilhelmina of the Netherlands inspecting the Princess Irene Brigade of the Dutch Army, which was quartered on the accommodation units of RAF Perton, much expanded, and renamed Wrottesley Park. She herself lived in a large house named Danescourt, on Perton ridge.

The headquarters building built just next to the main gates alongside the A41 Newport Road.

The headquarters building long after the war when it had been turned into a private house. It is now incorporated into the structure of a residential home.

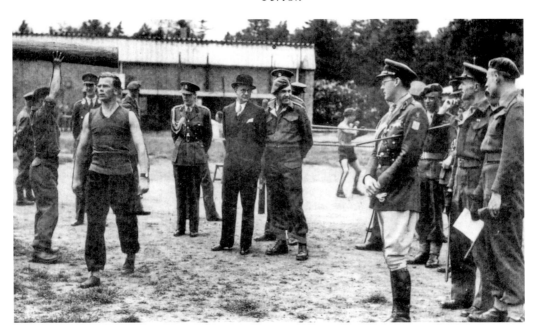

Above: Prince Bernhard watching training exercises. The Princess Irene Brigade left Wrottesley Park in September 1943 to prepare for the D-Day landings and took part in the liberation of their own country.

Right: One of the youngest Dutch soldiers stationed at Wrottesley Park was Ad Kramer, who was only eighteen years old when he moved there and stayed until 1947. Many soldiers stayed even longer, marrying local girls and settling in the Wolverhampton area. A plaque in Codsall church thanks the local people for their hospitality. The Dutch military cemetery in Jeffcock Road is an even more poignant reminder of the time.

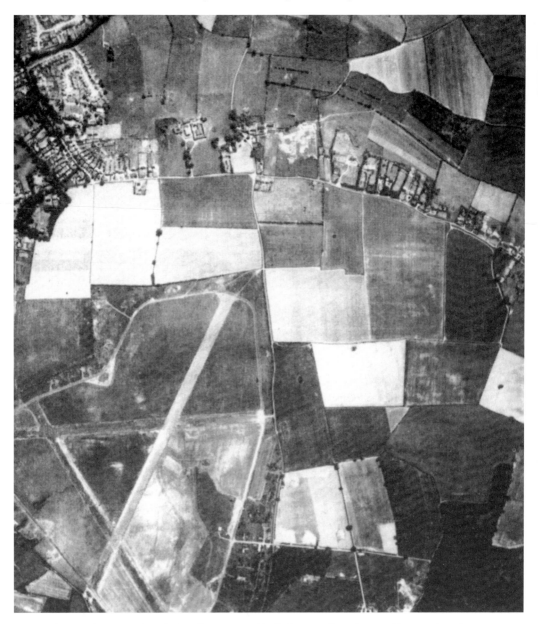

An aerial view of Perton taken during the 1970s, with the houses along Perton ridge running along the top. The Fern Fields, the First World War airstrip, lie just to the right of the end of the main runway. Glider Bank, at Clive Farm, is further to the right out of the picture. After the war my father, John Brew, became woodsman for the Wrottesley Estate, which covered most of this area.

Pendeford

Sir Alan Cobham toured Great Britain in 1929 in his de Havilland DH.61 Giant Moth, giving joy rides and promoting the idea that each town should have a municipal airport. He used Perton as his field near Wolverhampton, as he did subsequently with his Flying Circus, but when he was commissioned by the Town Council to recommend a site for a municipal airport in 1933, he chose Barnhurst Farm, Pendeford. Barnhurst was low-lying and prone to bogginess, but no doubt the fact that the Council already owned the farm swayed the decision.

In 1935 construction of the airport began on 132 acres of the farm, with a small hangar and a clubhouse/terminal. At the same time the former aircraft department of Boulton & Paul Ltd of Norwich, were looking for a new home. The aircraft department had been sold off to a consortium of businessmen lead by Sir Charles Masefield, and renamed Boulton Paul Aircraft Ltd. Sir Charles had been the chairman of AJS, one of Wolverhampton's many motor-cycle manufacturers, which had recently closed down. He regretted the loss of employment to the town, and was instrumental in bringing BPA to a greenfield site next to the new airport.

The first of over 600 workers from Norwich began to move to the unfinished factory late in 1935, and the rest followed by the following summer. The first aircraft rolling off BPA's production line was the Hawker Demon, the first of 106 flying on 21 August 1936. The Demons were followed by two turret fighters, 136 Blackburn Rocs and 1,062 of Boulton Paul's own Defiant, as well as the first of many gun turrets produced by the company to equip the Handley Page Halifax and American bombers bought for the RAF, in particular.

Civil flying at the new airport was to be undertaken by the Midland Aero Club, based at Castle Bromwich. Their aircraft were de Havilland Moth Majors, but in 1938 the proprietor of the *Express & Star* presented the club with a Foster-Wikner Wicko, a wooden, high-wing monoplane, for use with the government's new Civil Air Guard scheme. The Wicko was named *Wulfrun II*, but was not well liked by Wilfred Sutcliffe, the chief instructor. Strangely it still exists and is under restoration to fly.

The official opening of the airport did not come until 25 June 1938, inaugurated by the mayor, Councillor Probert and A. E. Clouston, recently in the news with a record-breaking flight to South Africa. The legendary Amy Johnson also took part with an aerobatic display in her Kirby Kite glider.

In February 1939 the club's Moth Majors were replaced by six Tiger Moths, a type soon to flood the airfield after the outbreak of war. The RAF took over Pendeford, in 1941, renaming it RAF Wolverhampton. The Derby organisation, Air Schools Ltd, formed No. 28 Elementary Flying Training School, and a huge building programme saw the construction of new huts and four Bellman hangars. A total of 106 Tiger Moths

were based at RAF Wolverhampton, and a satellite landing field at Penkridge was also brought into use. As well as RAF pilots, a large number of Turkish pilots were also given their elementary flight training at Wolverhampton, which was a very busy airfield. As well as the Tiger Moths buzzing around, there were the Defiants and later BPA-built Fairey Barracudas being test-flown, as well as assorted aircraft fitted with Boulton Paul's gun turrets, and though the airfield still retained only three grass runways, a tarmac taxiway was laid round the corner of Pendeford hill to BPA's flight sheds.

After the war the airport returned to civil flying on 1 January 1946, and Wolverhampton Aviation, a division of Air Schools of Derby operated the resident flying club, using initially a few Miles Magisters. There was still a resident RAF unit for a while, No. 25 Reserve Flying School with Avro Ansons, and later Percival Prentices, giving refresher flying to RAF reserve pilots, but this closed in 1952. Don Everall Aviation Ltd took over the running of the airfield, and briefly, during the mid-1950s, scheduled services by Don Everall and by Derby Aviation (the forerunner of British Midland) were operated to the Channel Islands and the Isle of Man.

Housing began to encroach on the airfield and questions were raised about its future viability. On 9 April 1970 a de Havilland Dove of McAlpine Aviation, attempting to land in poor weather to pick up Dowty Boulton Paul executives to take to France, crashed, striking a house in Redhurst Drive. Three people died and this proved the last straw for the airport, which was closed in 1971. Like its neighbour, Perton, it was soon engulfed in housing, and the only clue that there once was an airfield there is the fine sculpture of three Defiants next to the Droveway.

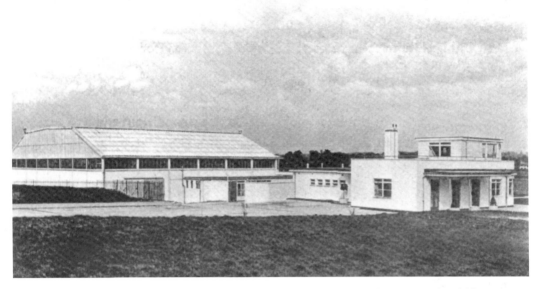

The brand new Wolverhampton Airport buildings in 1937, just a single hangar and a clubhouse/terminal.

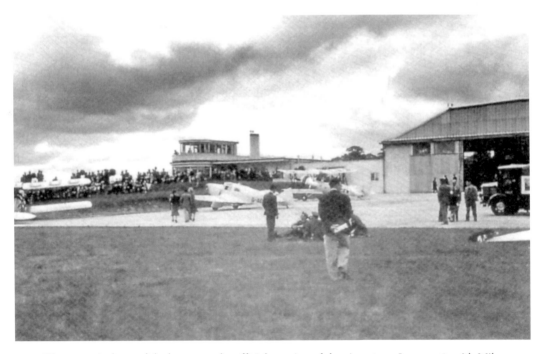

The apron in front of the hangar at the official opening of the airport, 25 June 1938, with Miles Falcon Six, G-ADLC and Avro Tutor, G-ACFW, and to the left the Midland Aero Club Moth Major, G-ACOG.

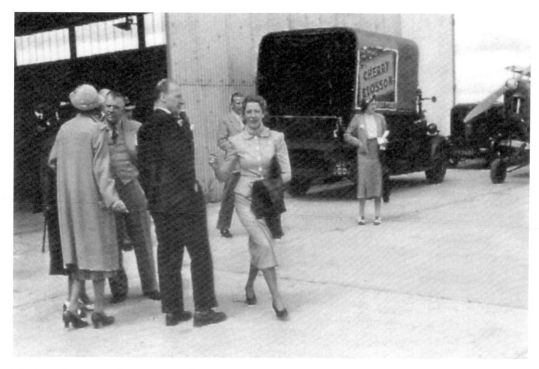

The legendary Amy Johnson striding from the hangar during the opening-day display, in which she performed aerobatics in her Kirby Kite glider.

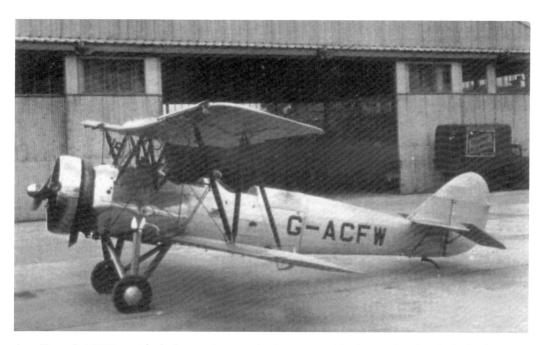

Avro Tutor, G-ACFW, outside the hangar. It was to be demonstrated in the opening-day air display by Avro's test pilot, S. A. Thorn.

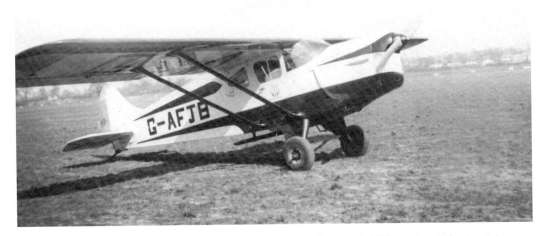

In 1936 the government instituted the Civil Air Guard scheme, subsidising private pilots' training, provided they joined the services in times of war. The proprietor of the *Express & Star* saw this aircraft, the Foster-Wikner Wicko, demonstrated at Castle Bromwich, and immediately bought it to present to the Midland Aero Club for use in the scheme. It was registered G-AFJB, named *Wulfrun II*, and is shown at Pendeford.

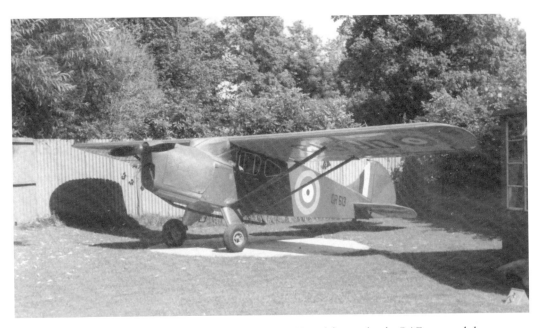

During the Second World War, the Wicko was requisitioned for use by the RAF, renamed the Warferry and given the serial DR613. Although returned to private ownership after the war, when preserved by a Coventry man in his garden, shown here, it was repainted in its wartime colours. It is now being rebuilt to flying condition.

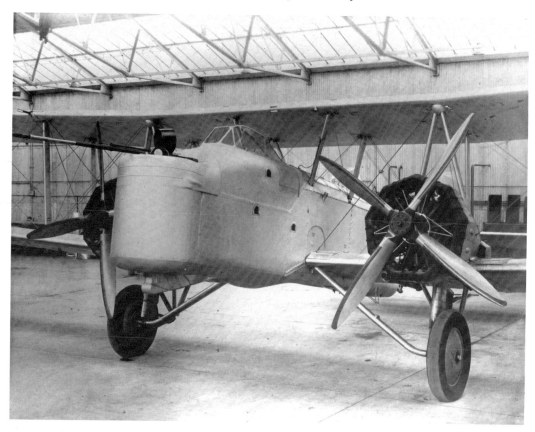

Boulton Paul retained one of their Overstrand bombers, all of which had been built in Norwich, at Pendeford for armament development work. The Defiant's turret was first test-flown in this, replacing the aircraft's own nose turret, and it is shown here with a 20 mm Hispano-Suiza cannon, on a French SAMM mounting. The aircraft is in the new flight shed, which was built alongside the canal at the rear of the factory. The Overstrand was K8175, and was camouflaged after the war began. It crashed while landing at Blackpool during a thunderstorm, being flown to Scotland by test pilot, Robin Lindsay Neale.

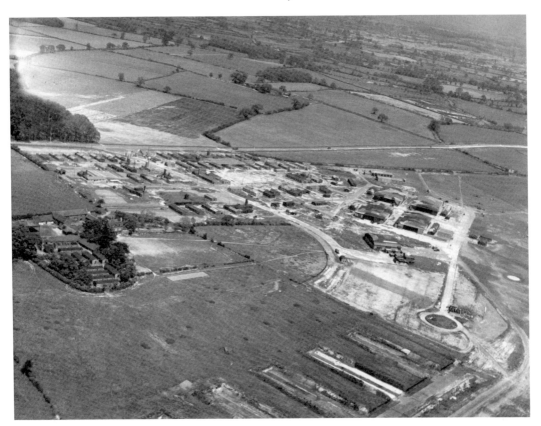

An aerial view of the extensive new RAF buildings erected during the war, with the original hangar just below the four new Bellman hangars to the right, and Pendeford Hill Farm to the left. At the bottom are five blast pens cut into the hillside by the taxiway to the Boulton Paul factory, in each of which two aircraft could be parked.

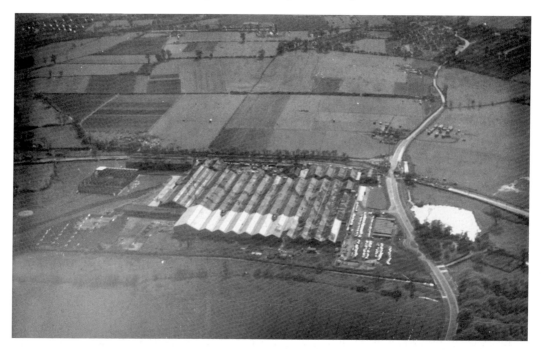

The Boulton Paul factory looking towards Bilbrook village in the background. Most of the factory is camouflaged but the shiny new roof of the new gun turret factory stands out, and two Bellman hangars are being erected as extra flight sheds to the left of the hardstanding at the rear. There are lots of cars parked at the front of the factory alongside a phalanx of bike sheds. As the war progressed turret production was transferred to Joseph Lucas in Birmingham, and only development work was retained at Pendeford.

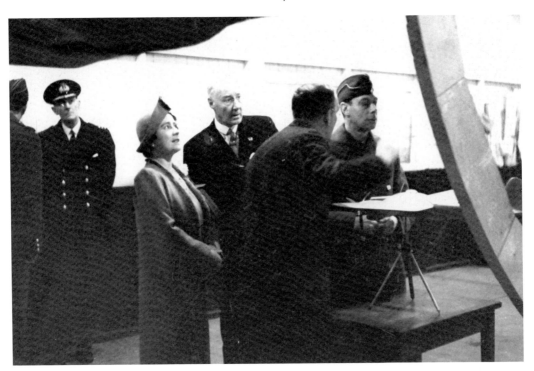

The King and Queen visiting the Boulton Paul factory in 1940. Lord Sandon, the company chairman is next to Queen Elizabeth, and they are viewing a mock-up of the Defiant's potential replacement, the P.92, a model of which is just in front of King George.

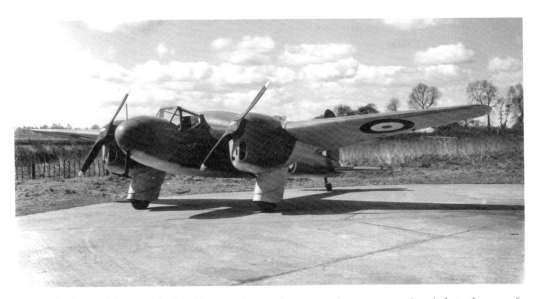

A half-scale flying model of the P.92 standing on the company's compass turning circle to the rear of the factory. This aircraft, designated the Boulton Paul P.92/2, was actually built by Heston Aircraft. The P.92 was to have a turret with four 20 mm cannons, but was cancelled when the prototype was 5 per cent complete.

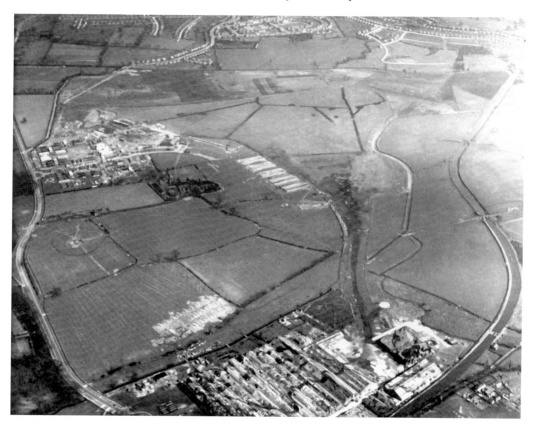

A wider aerial view showing the camouflaged Boulton Paul factory at the bottom, linked by a tarmac taxiway to the RAF buildings. The grass airfield itself (above the taxiway) is disguised with painted 'hedgerows', which can be compared to the real hedgerows on Pendeford Hill around the anti-aircraft site by the farm.

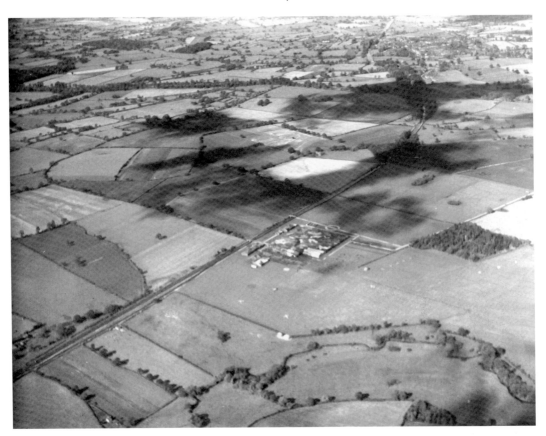

The dummy Boulton Paul factory built about a mile north of the real one, with dummy aircraft on the dummy airfield. It did not fool the Germans, as their bombing maps showed both the real and dummy sites. There was a solitary bombing attack on Pendeford during the war when one Sunday evening a single Junkers Ju.88 emerged from low cloud, dropped a stick of bombs which fell on Barnhurst sewage works, and was escaping over Bushbury Hill before the anti-aircraft gunners awakened from their slumbers and opened fire.

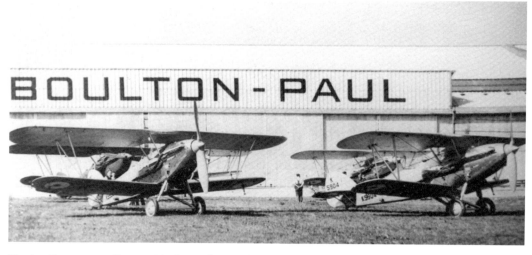

Hawker Demons standing outside the Boulton Paul factory, awaiting delivery. The one on the right, K5904, went to No. 29 Squadron, then No. 64, and two training units before being struck off charge in December 1940.

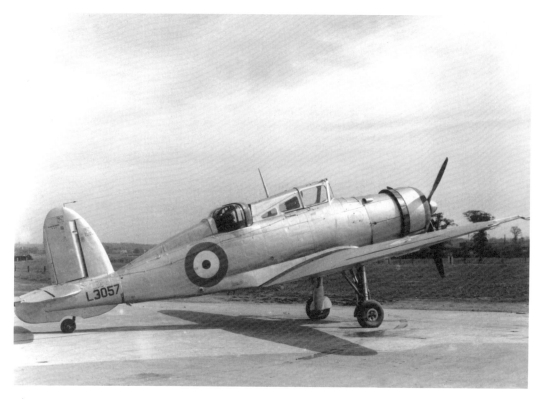

The prototype Blackburn Roc, L3057, at Pendeford. The retractable fairings each side of the turret are raised in the streamlined position, though no guns are fitted. The Roc saw a small amount of action during the Norwegian campaign and over Dunkirk, but was soon relegated to use as a target tug.

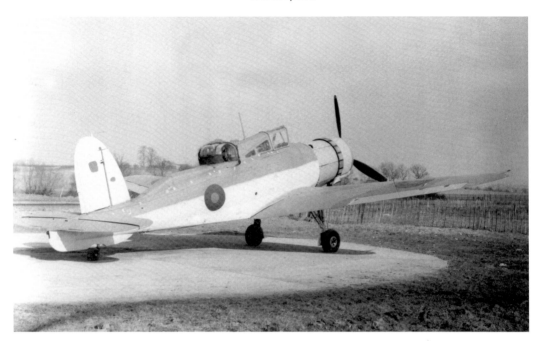

A production Blackburn Roc on the compass swinging circle outside the Boulton Paul factory, no guns yet fitted to its turret, but the rear fairing is lowered. No amount of streamlining could mitigate the Roc's hopeless performance.

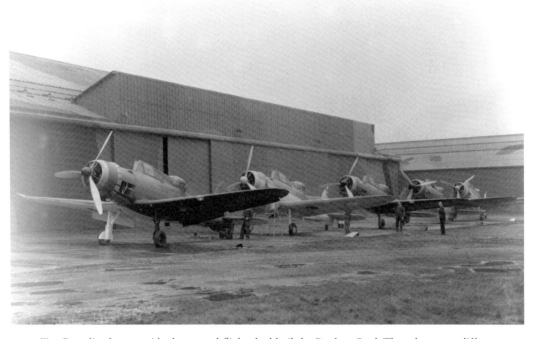

Five Rocs lined up outside the second flight shed built by Boulton Paul. They show two different camouflage schemes; the first one with the early-war undersides of half black and half white.

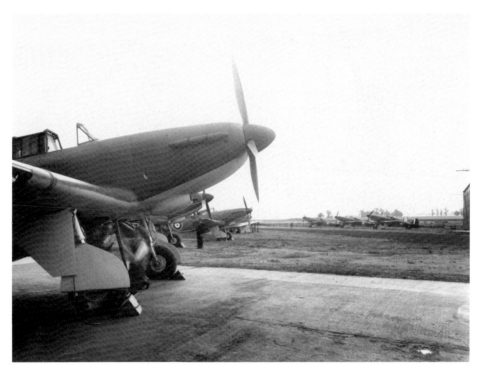

Boulton Paul Defiant day fighters awaiting delivery outside Boulton Paul's flight sheds. The blurred figure of a fitter is between the wheels of the first one. For a brief period over Dunkirk and in the early days of the Battle of Britain, two squadrons of Defiants fought as day fighters, but as the Blitz began, up to seven squadrons at a time were allocated to night fighting.

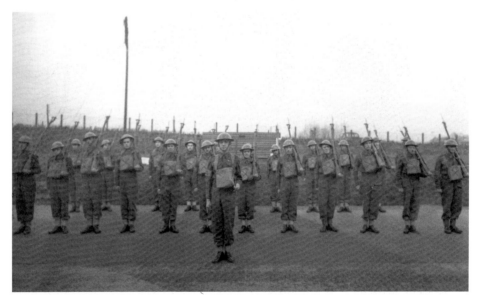

The Boulton Paul Home Guard platoon stand to attention, bayonets fixed, on the car park at the front of the factory. The grass area behind them covered an air-raid shelter.

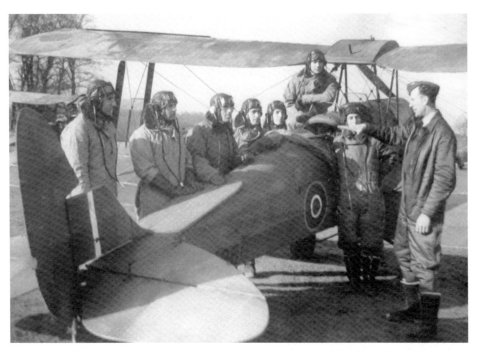

Among the pilots trained at No. 28 EFTS were a batch of Turkish pilots, shown here by one of the School's Tiger Moths.

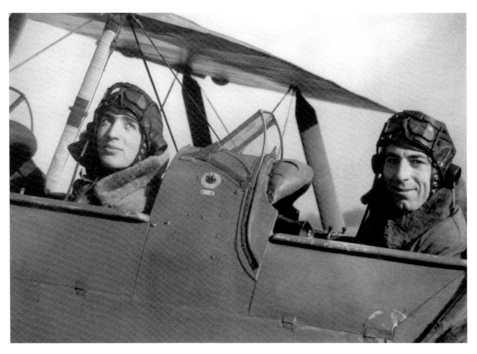

A Turkish pilot in the front seat of a Tiger Moth, with one of the Air School's instructors behind.

A Turkish cadet, still wearing his parachute, receives instruction on the ground from an instructor in his Sidcot flying suit.

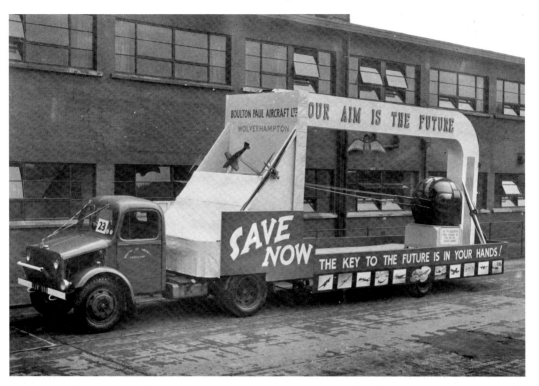

Part of a parade through the town, a Boulton Paul float featuring a Type E Halifax tail turret, and extolling the benefits of saving for the war effort.

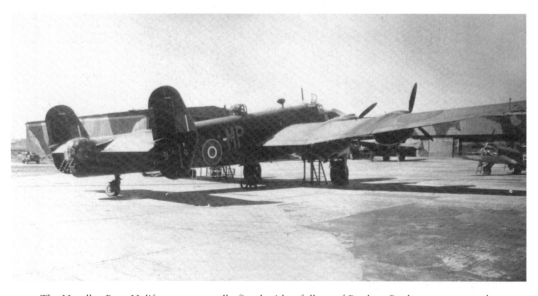

The Handley Page Halifax was normally fitted with a full set of Boulton Paul gun turrets, and this one is shown at the rear of the factory to test a new Type T dorsal turret with two 0.5 inch Brownings. This turret was cancelled shortly after testing commenced. The Defiant in the background is probably the prototype mark II.

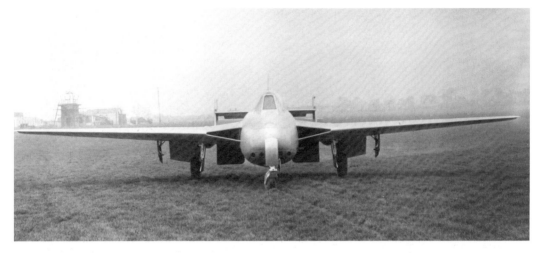

A Rolls-Royce Nene-powered de Havilland Vampire, fitted with new intakes by Boulton Paul, and test-flown from Pendeford's grass runways. The control tower in the background is just having an observation room built on the top.

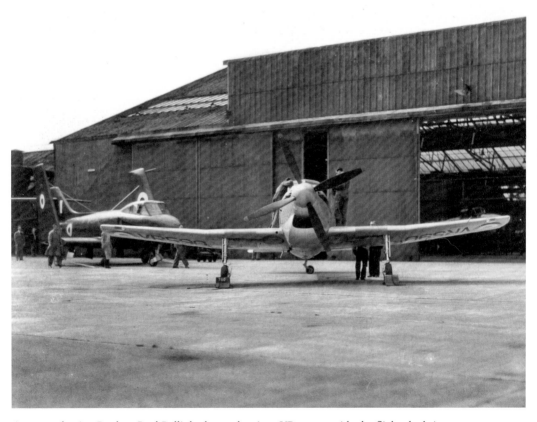

A pre-production Boulton Paul Balliol advanced trainer, VR590, outside the flight sheds in 1950, with the elaborate mock-up of the company's P.119 jet trainer project behind.

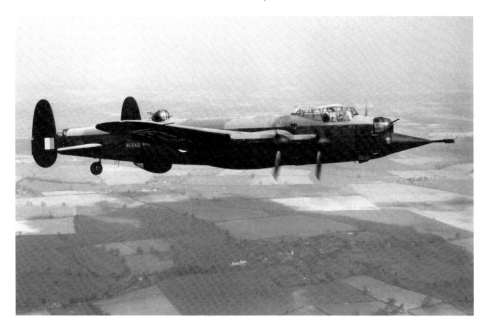

Avro Lancaster ME540 flying near Pendeford. The nose probe was part of a gust alleviation system under test for the Bristol Brabazon. The probe detected gusts in the air, and the ailerons were then moved up or down automatically to counteract it, thereby, hopefully, giving a smoother flight.

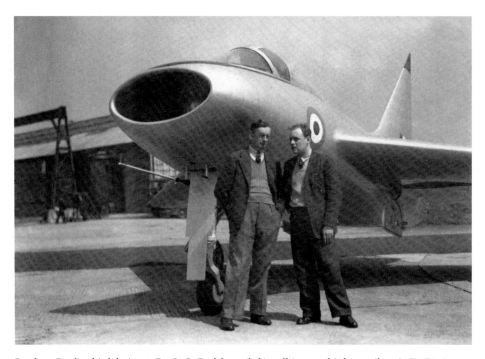

Boulton Paul's chief designer, Dr S. C. Redshaw (left), talking to chief test pilot, A. E. (Ben) Gunn, in front of the P.111 experimental delta wing jet behind the factory.

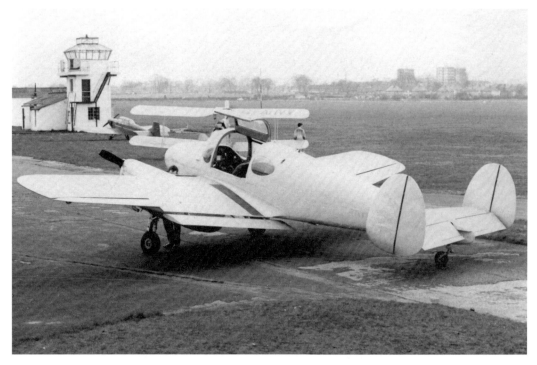

One of six Miles Geminis assembled from parts by Wolverhampton Aviation after the demise of the Miles company.

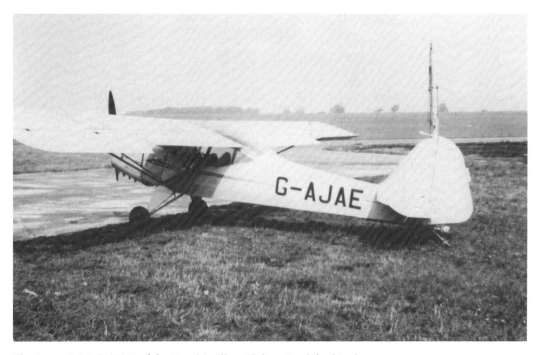

The Auster J.1N, G-AJAE, of the Royal Artillery Club, at Pendeford in the 1950s.

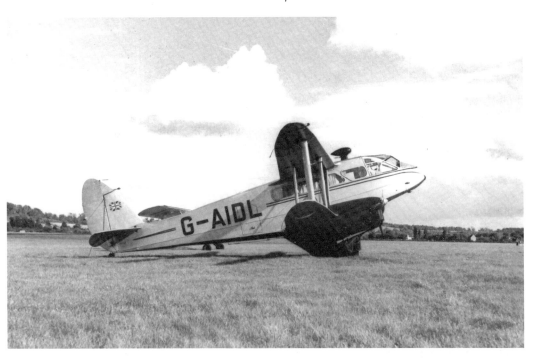

De Havilland Dragon Rapide, G-AIDL, owned for many years by Fox's Glacier Mints, at Wolverhampton. The Rapide was a type frequently to be seen at Pendeford in the 1950s and '60s, with several such aircraft based there.

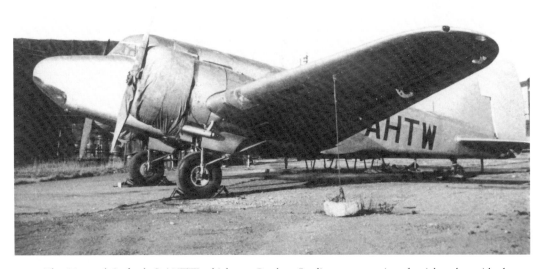

The Airspeed Oxford, G-AHTW, which was Boulton Paul's corporate aircraft, picketed outside the flight sheds in the late 1950s. It later went to the Skyfame Museum at Staverton, and then Duxford, where it is now suspended in the superhangar, in RAF camouflage.

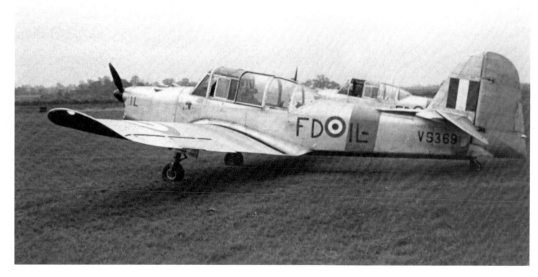

Percival Prentices of No. 25 Reserve Flying School, which provided refresher flying, with Avro Ansons, for RAF reserve pilots at Wolverhampton after the war. Shown on 26 May 1951, No. 25 RFS closed not long afterwards.

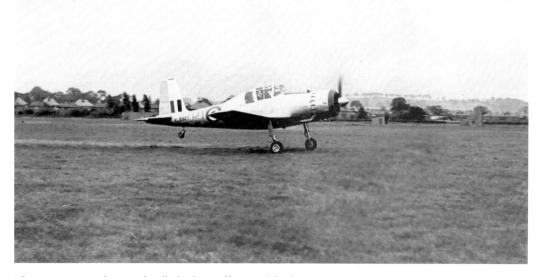

The prototype Boulton Paul Balliol taking off at Pendeford. Powered temporarily by a Bristol Mercury engine, because the Mamba turboprop was not ready, the Balliol was designed to be the RAF advanced trainer, which would have followed the Prentice in the flight-training syllabus.

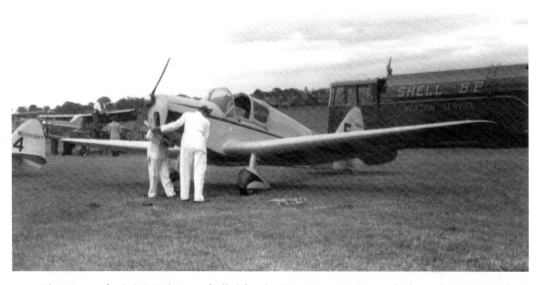

The Mosscraft, G-AFMS, being refuelled for the King's Cup Air Race, which was held at Pendeford for the only time in June 1950. H. Moss came tenth in the race, but another Mosscraft, G-AEST (no. 4 to the left) crashed during the race.

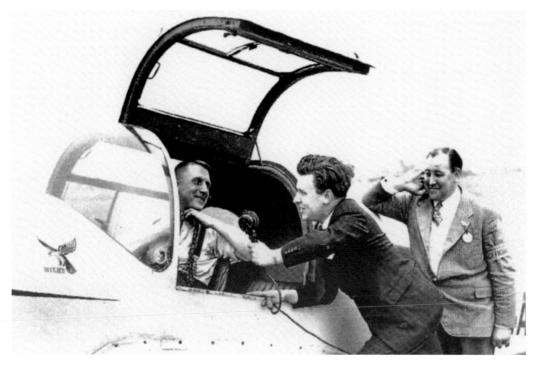

Fred Dunkerley being interviewed for radio in the pilot's seat of his Miles Mercury after winning the Goodyear air trophy race.

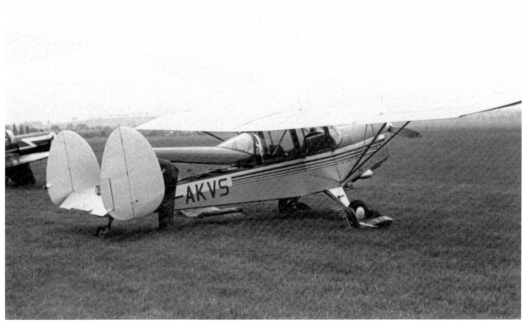

The Chrislea Skyjeep, G-AKVS, which came twenty-seventh in the King's Cup Air Race, shown here the following year when the Goodyear air trophy race was held in May. The Goodyear trophy race was an annual event at the airport.

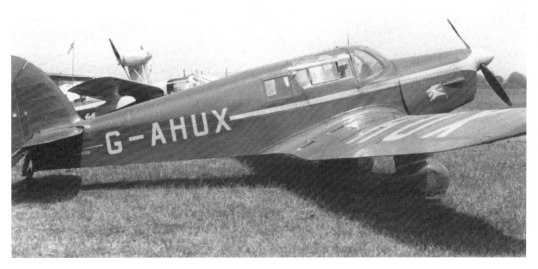

The Percival Proctor, G-AHUX, at Pendeford in 1948. The aircraft behind is a Goodyear Duck, a two-seat light aircraft produced in small numbers by Goodyear after the war, on a promotional visit. The Goodyear factory is a little further down the Stafford Road.

An impressive line of Austers, the mainstay of British light-aircraft flying in the 1950s, not least at Pendeford, where a number were used for flying instruction by the Flying Club.

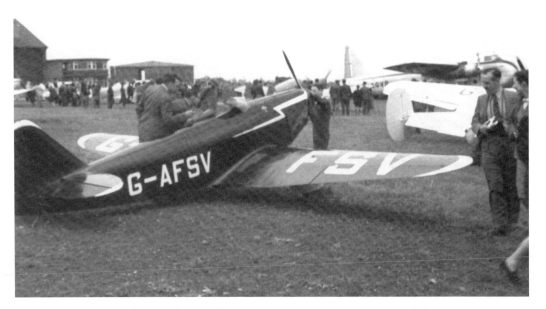

The Chilton DW.1A monoplane, G-AFSV, preparing to take part in the annual Goodyear trophy race. The Bristol Freighter in the background was at Pendeford for the making of the Jack Hawkins' film, *The Man in the Sky*.

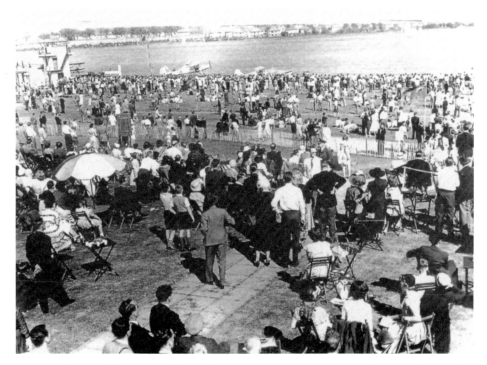

A view of the crowd from the clubhouse for the 1952 air display and Goodyear trophy. On the ground is a Fieseler Storch, operated by the Royal Aircraft Establishment.

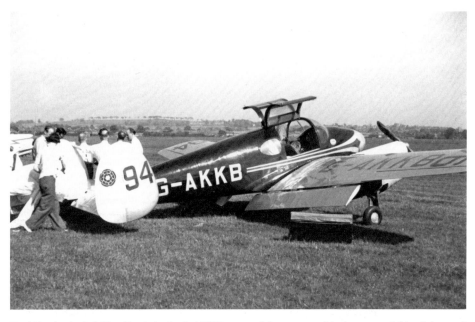

Fred Dunkerley's Miles Gemini 1A, G-AKKB, on 17 May 1952, with the perennial backdrop of so many Pendeford photographs, Bushbury Hill. Fred Dunkerley was a common entrant for air races in the 1950s, and one of a group sometimes known as 'The Throttlebenders'.

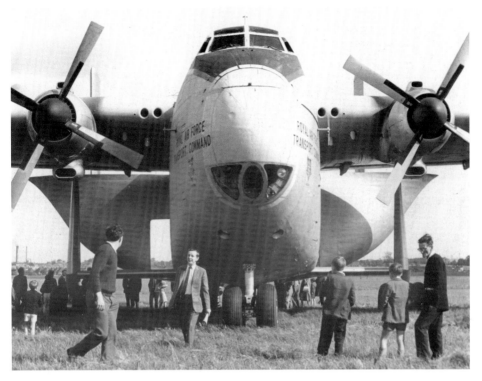

Easily the largest aircraft ever to land at Pendeford, the Blackburn Beverley, which took part in the 1965 Royal Air Force Association Display.

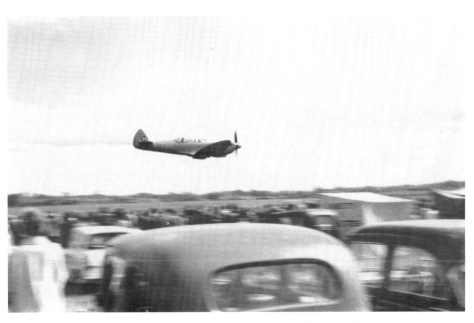

Low and fast, the pale-blue two-seat Spitfire, G-AIDN, owned by Vic Bellamy, for a time the only Merlin-engined Spitfire regularly seen at British air displays, here at Pendeford in 1965.

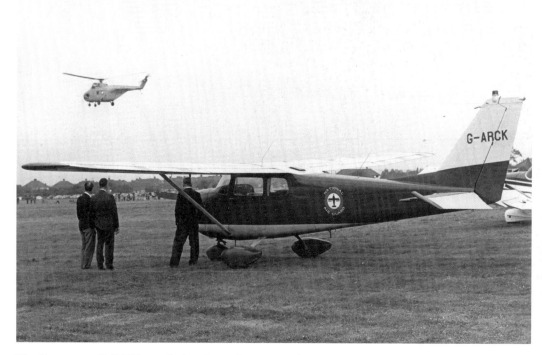

The Cessna 175, G-ARCK, attached to the civilian National Air Guard, at Pendeford in the 1960s, with a Gnome-powered Whirlwind lifting off.

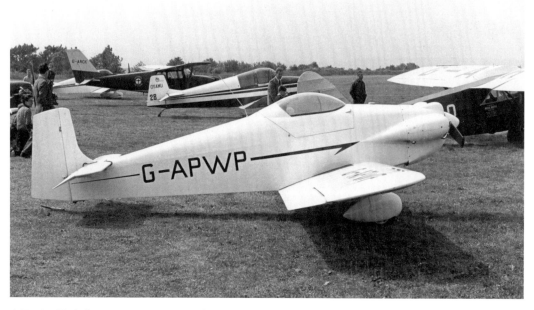

A Druine Turbulent, G-APWP, at a Popular Flying Association Rally at Pendeford, and deporting a very unusual cockpit canopy, most Turbulents having open cockpits.

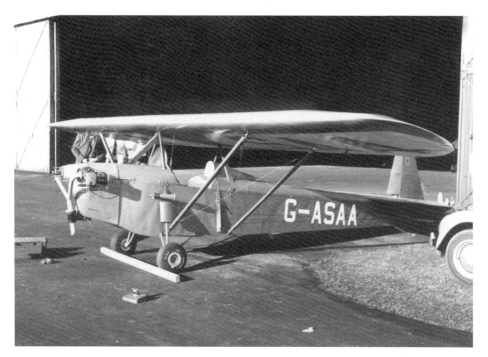

The prop-less Luton Minor G-ASAA, outside the main hangar at Pendeford. Only one of the four wartime Bellman hangars was used post-war for aircraft, the other three being rented to Goodyear for storage. The pre-war hangar was mainly used for maintenance.

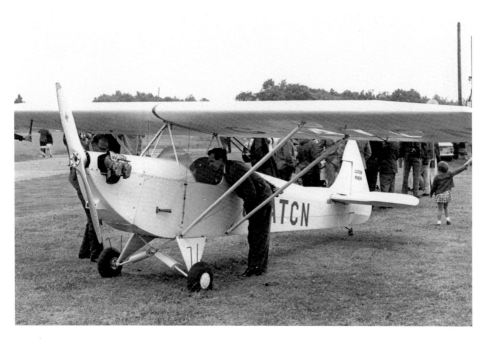

Another Luton Minor, G-ATCN, visiting Pendeford for a Popular Flying Association Rally in the 1960s.

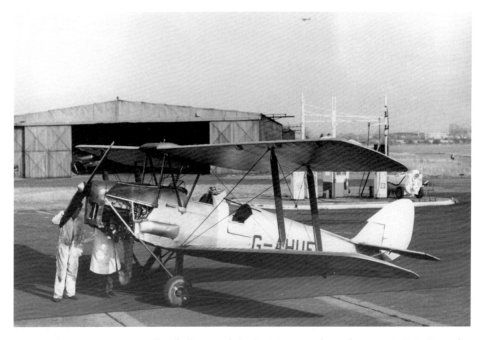

Perhaps the most common sight of all at Pendeford, a Tiger Moth, in this case G-AHUE, on the apron near the refuelling pumps. The nose of a civilian Percival Provost, G-ASMC, can just be seen in the hangar behind.

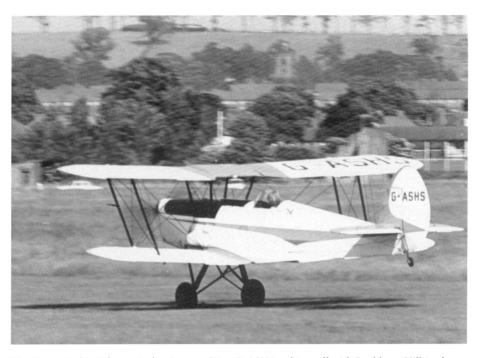

The Tiger Moth's Belgian rival, a Stampe SV.4, G-ASHS, taking off with Bushbury Hill in the background. This is a Tiger Club Stampe reconfigured as a single-seater, for aerobatics.

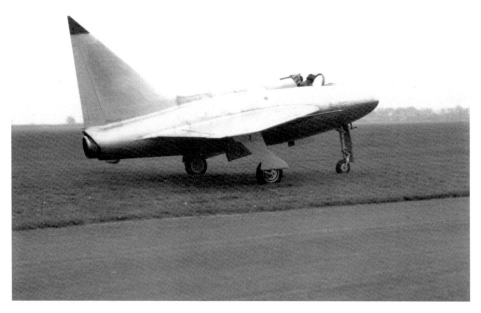

The Boulton Paul P.111 delta wing research jet undergoing taxiing trials on Pendeford's grass, at the hands of Chief Test Pilot A. E. (Ben) Gunn. The aircraft never flew from Pendeford, as it needed a very long tarmac runway, but the taxiing trials did discover a tendency for the initial tyres fitted to cause a shimmy in the nose-wheel. The nose-wheel tyre was thus changed before the first flight.

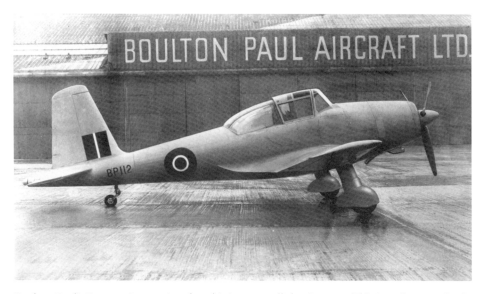

Boulton Paul's P.112 trainer project, but this is not at all that it seems. This is a photograph of the Mamba-powered P.108 Balliol trainer, re-touched by an artist to look like the P.112, which was never built. The same effect would be achieved by computer-controlled graphics these days, but really there's nothing new under the sun.

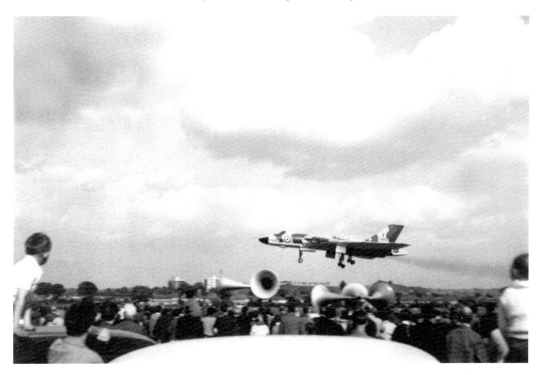

The RAFA Air Show of 1967 featured this Avro Vulcan doing a low pass, wheels down, no doubt followed by a *very* noisy climb away. The Vulcan is of course a very rare sight in the air these days, since there is only one.

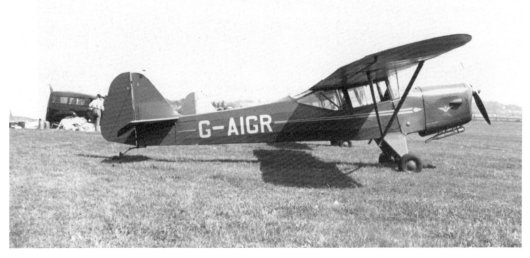

An Auster J/1 Autocrat, the epitome of British 1950s club flying, not least at Pendeford, where it was photographed in May 1952. This one, G-AIGR, was later converted to a J/1N Alpha, by having its Blackburn Cirrus Minor engine replaced by a de Havilland Gipsy Major, allowing it to carry four people rather than three.

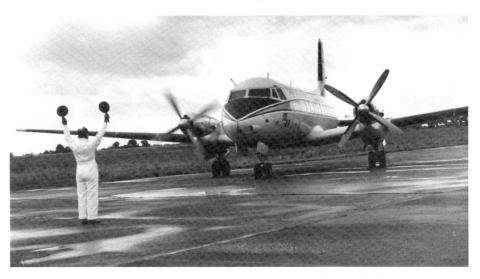

A Skyways Avro 748 airliner bringing a French delegation to Boulton Paul, for discussions about the Concorde power controls, which the company was building. This was the largest civil airliner to land at Pendeford.

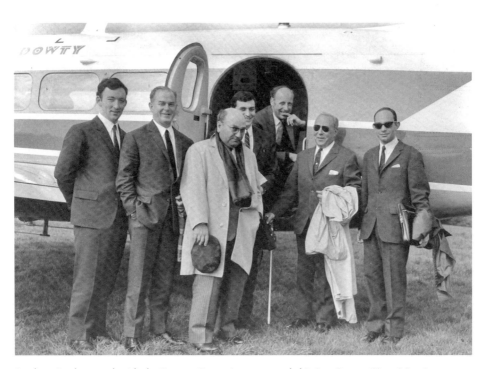

Boulton Paul merged with the Dowty Group in 1961, and this is a Dowty Piper Navajo bringing a Rumanian delegation to Pendeford, one of the last corporate flights. It was the crash of a de Havilland Dove, hired by Dowty, trying to land in adverse weather conditions on 9 April 1970 that was perhaps the final straw for the airport, which closed on 31 December 1970. Boulton Paul had been granted 100 years of flying rights to help entice them to Wolverhampton, but they waived these rights, and Pendeford became another housing estate.

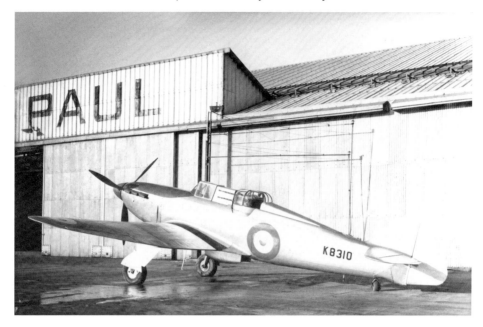

A total of 1,062 Boulton Paul Defiants flew from Pendeford, more than any other type. This is the first, the prototype, K8310, shown in 1938 just after having its iconic four-gun turret fitted. It stands expectantly, shining in the sun, after the rain, and became Wolverhampton's highest profile contribution to the Second World War.

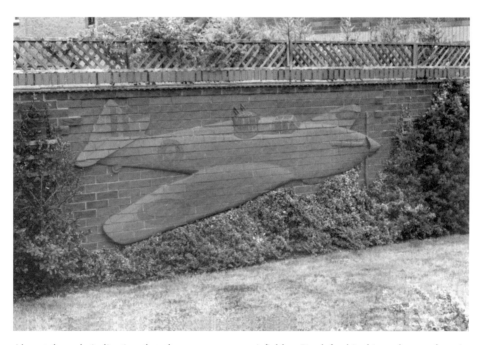

Almost the only indication that there ever was an airfield at Pendeford is this sculpture, done in relief in the brickwork at the edge of the Droveway. One of three Boulton Paul Defiants which were carved in the raw clay by the artist in the Baggeridge brick factory at Sedgeley.

Halfpenny Green

With the expansion of the Royal Air Force during the late 1930s, in 1938 a site between the villages of Bobbington and Halfpenny Green was designated to become a volunteer reserve centre. During 1939 the land was requisitioned and an airfield straddling Crab Lane was built by Wolverhampton company, Sir Alfred McAlpine, with seven Bellman hangars in a group and eleven blister hangars around the perimeter. The airfield was named RAF Bobbington, after the largest nearby village. It was later in the war that it was renamed RAF Halfpenny Green, to avoid confusion with RAF Bovingdon.

In 1941 No. 3 Air Observers Navigation School was opened equipped with fifty Blackburn Bothas. These twin-engined torpedo bomber/reconnaissance aircraft had quickly been rejected for operational service as they were seriously underpowered, something which caused further problems in the training role. The main unit was renamed No. 3 Air Observers School and re-equipped with forty-four Anson Mk.Is with half a dozen target tug aircraft, Lysanders and then Miles Martinets.

At the end of the war, No. 3 (O) AFU was disbanded and the airfield placed on a care and maintenance basis. With the crisis caused by the Korean War, the station was refurbished and reopened as the home for No. 2 Air Signallers School with ten Percival Prentices and ten Avro Anson C.19, T.21 and T.22 aircraft. Flying continued until the late summer of 1953, when the unit disbanded and the airfield was again placed on the inactive list.

In 1961 ex-RAF civil flying instructor, Ted Gibson, approached the Air Ministry with a plan to reopen Halfpenny Green for civil flying. He was granted a lease for the airfield and half a hangar, and moved in an Auster Alpha, G-APTR, in March. Later in the year a consortium of local businessmen, as Bobbington Estates Ltd, bought the airfield. By the end of 1962, Halfpenny Green Flying Club had four aircraft, two Austers and two Piper Tri-Pacers, and there were also fifteen privately-owned light aircraft based there, some moving over from Wolverhampton Airport.

The first fly-in was organised by the Vintage Group of the PFA in 1965, and the following year the Goodyear air trophy race was staged at Halfpenny Green for the first time. Air shows and air races were to be a feature of the airfield for many years. The airfield became the de facto airfield for Wolverhampton with the closure of Pendeford in 1971, and this was later to be reflected in a name change to Wolverhampton Business Airport, now modified to Wolverhampton Halfpenny Green Airport.

Various plans for the development of the airfield have come and gone, including a brief dalliance, fiercely resisted locally, for a major expansion to take regional jet airliners. Now owned by Mar Properties, the Green continues to be a lovely local amenity used for business flights, home to the police helicopter unit, and enjoyed by the leisure-flying community.

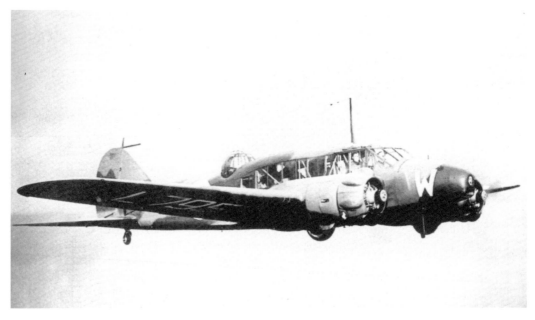

An Avro Anson I, L7951, coded 'W' of No. 3 Air and Navigator School at Halfpenny Green early in the war. This aircraft later went to the South African Air Force and served until 1946.

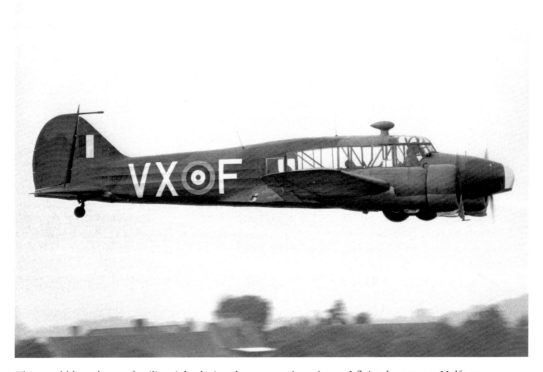

This would have been a familiar sight during the war: an Avro Anson I flying low across Halfpenny Green, but in this case it is the Skyfame Museum's example, N4877, now preserved at Duxford.

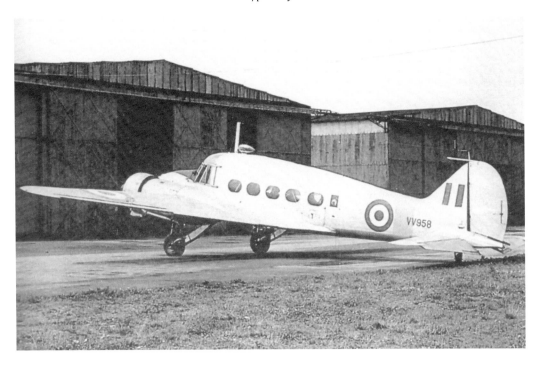

An Anson T.21, a small number of which served alongside T.22s and Percival Prentices in No. 2 Air Signaller's School during the Korean War period when Halfpenny Green was reactivated. Like several Ansons that were sold to civil operators, this aircraft went to Mercy Missions as G-AWMG, and crashed in Biafra during the Nigerian Civil War.

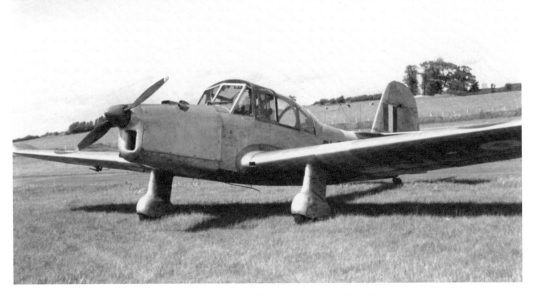

Photographed in May 1953 at Pendeford, the Percival Prentice, like VS381 shown here, was in service at Halfpenny Green for the Korean War reactivation of the airfield.

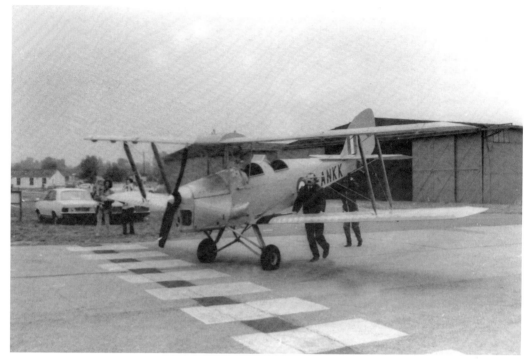

Continuing the Tiger Moth theme of Wolverhampton's airfields, this is the all-yellow G-ANKK at Halfpenny Green in the 1960s, being wheeled out for a flight. This aircraft is now based at Baxterley in Warwickshire.

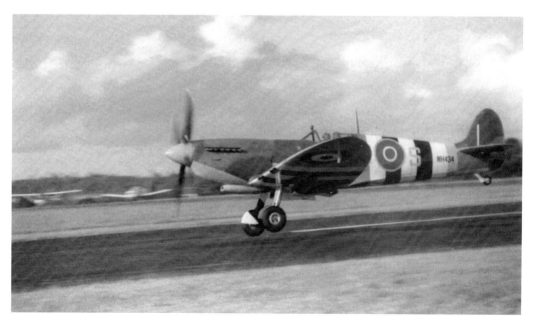

Like the previous photograph, this could almost be a wartime shot. It is the Spitfire Mk.IX, MH434, landing at Halfpenny Green during the 1969 Air Show.

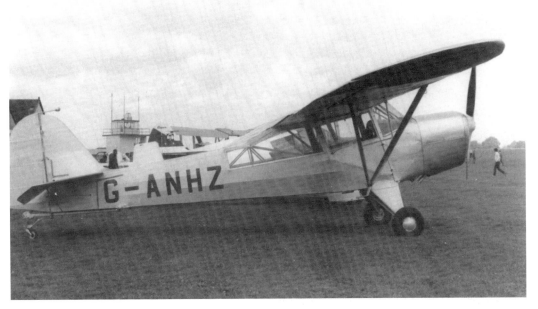

The Taylorcraft Auster V, G-ANHZ, parked near the control tower at Halfpenny Green during the 1960s. Unlike Pendeford, Halfpenny Green never had a large resident population of Austers.

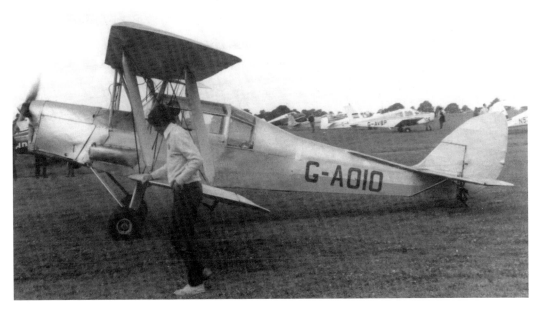

The four-seat conversion of the Tiger Moth, the Thruxton Jackeroo, G-AOIO, taxiing in from the runway.

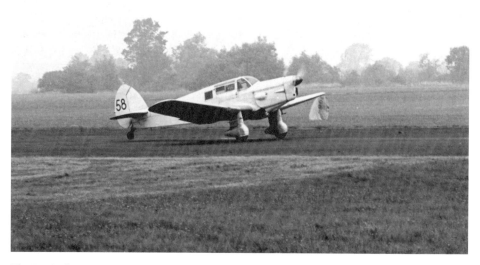

The Percival Proctor, G-AGWB, taking part in the 1966 Goodyear air trophy race. For many years the Air Scouts based on the airfield owned a Proctor, G-AOBI, a former resident at Pendeford.

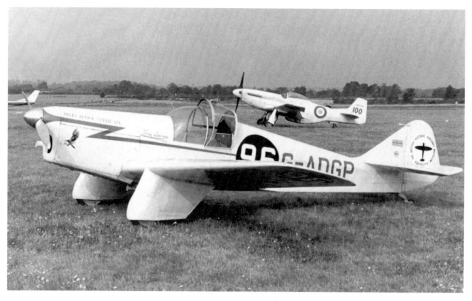

Two iconic aircraft together at Halfpenny Green. The Miles Hawk Speed Six, G-ADGP, formerly owned and raced by Ron Paine, after being gifted to the British Historic Aircraft Collection at Southend, here in front of Charles Masefield's North American Mustang, in its early white incarnation; it was later to reappear at Halfpenny Green in a smart red scheme.

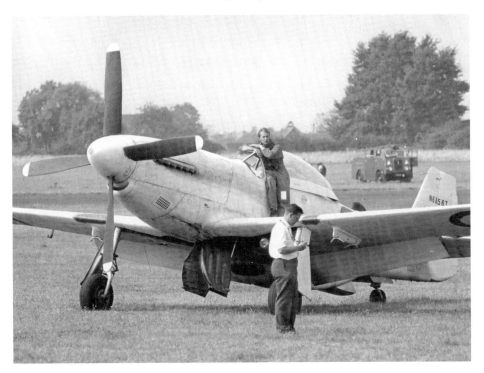

Charles Masefield on his Mustang, N6356T, at a time when such warbirds were extremely rare in Great Britain. For some reason the aircraft has bomb racks under the wings, even though it was taking part in the 1968 Goodyear trophy.

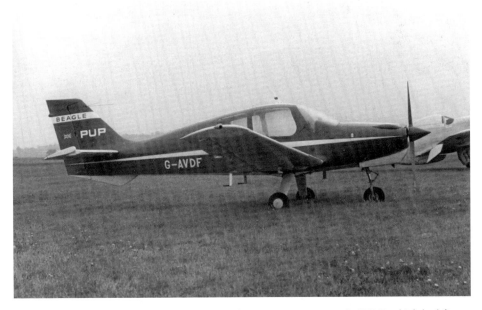

Visiting at the same time as the Mustang, Beagle Pup 100 prototype, G-AVDF, which had first flown the year before, and undertook a demonstration flight during the show.

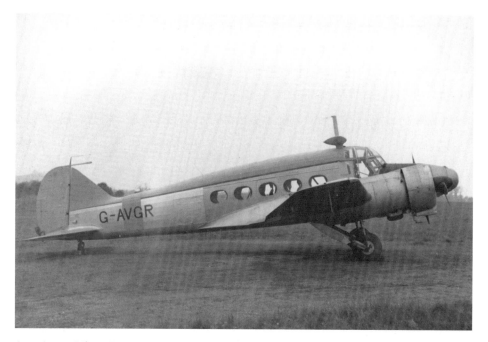

Avro Anson Mk.19 Series 2, G-AVGR, one of a number of Ansons retired from the RAF, which were to be parked around Halfpenny Green for a while in the late 1960s, giving something of the wartime flavour to the airfield once more.

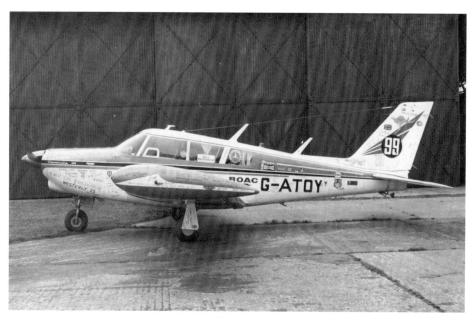

A very famous aircraft at Halfpenny Green, the Piper Comanche, G-ATOY, in which Sheila Scott flew around the world. It is covered with the signatures of many of the people she met along the way. The racing number 99 reflects the association of women flyers, of which she was a member. She raced G-ATOY in Ninety-Niner races at Halfpenny Green.

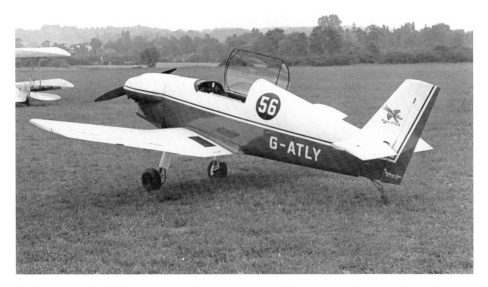

Rollason Beta, G-ATLY, of the Tiger Club, one of several Betas that took part in Formula One air races at Halfpenny Green.

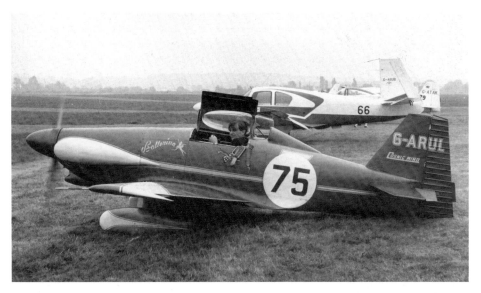

Another Formula One Racer, but of much older vintage, the Cosmic Wind, G-ARUL, *Ballerina*, with Bill Innes in the cockpit. Taking part in the 1969 Goodyear air trophy race, possibly minutes after this photograph was taken, he rounded the first pylon, just after taking off, and crashed in a field just beyond the airfield. Innes was severely injured but survived, and the aircraft was eventually rebuilt.

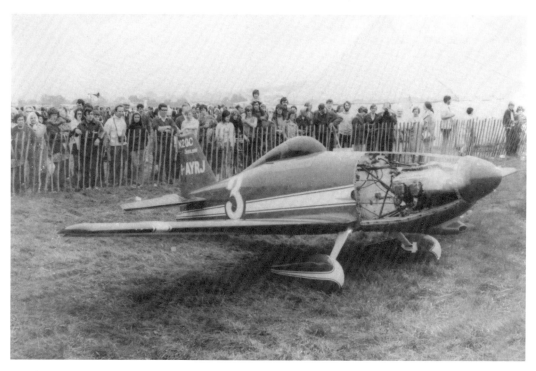

Another Le Vier Cosmic Wind at the Green, G-AYRJ, formerly N20C, which took part in several Goodyear Formula One races from 1970.

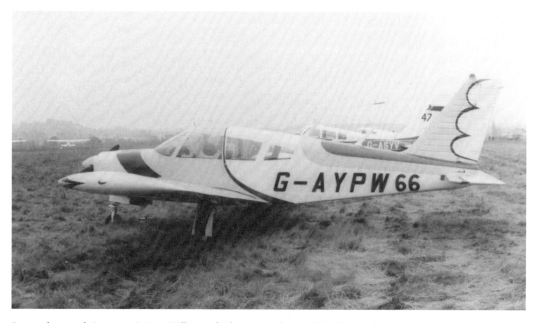

In another crash in 1972, Prince William of Gloucester, the ninth in line to the throne, was piloting this Cherokee Arrow, G-AYPW, in the Air Trophy Race, when he crashed and died, along with his co-pilot. This photograph was also taken only minutes before the race.

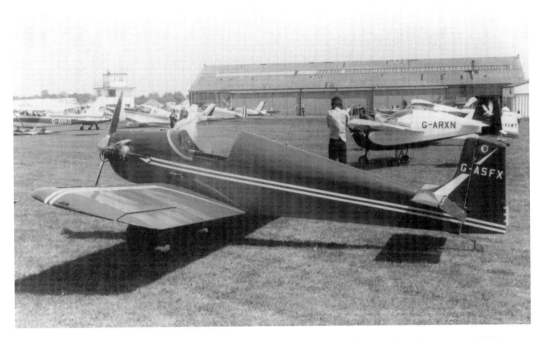

The Druine D.31 Turbulent, G-ASFX, at a Halfpenny Green air show during the 1970s, with Tipsy Nipper, G-ARXN, just behind.

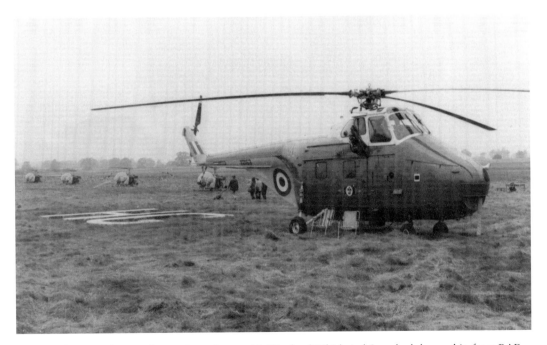

At the same show as the previous picture, this Westland Whirlwind Srs.3 had dropped in from RAF Shawbury, and is parked by the 'HG' of the signal square, with four Army Bell Sioux helicopters behind.

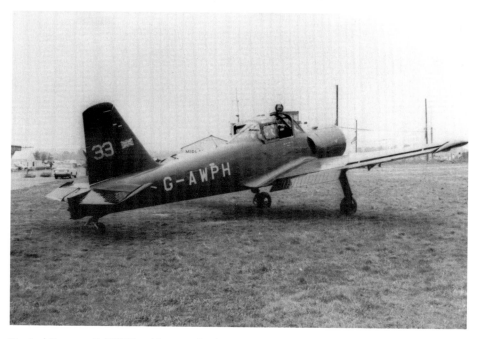

Percival Provost, G-AWPH, taking part in the 1971 Goodyear trophy race, following another Provost, G-ASMC, the year before.

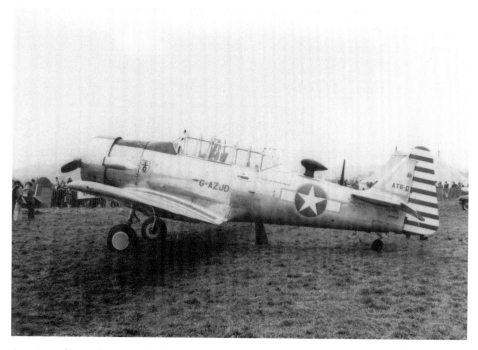

A trainer of an earlier era, which nevertheless overlapped that of the Provost, the North American Harvard G-AZJD, owned at the time by the Strathallan Collection in Scotland, but later based at Biggin Hill.

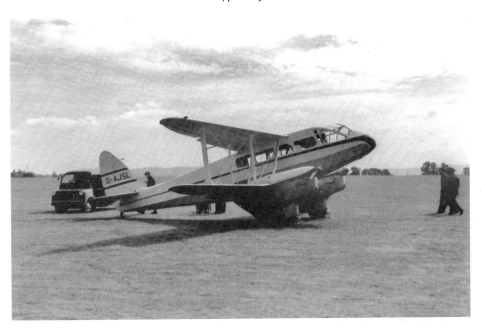

The de Havilland Rapide of the Parachute Regiment's Free Fall Club, at Halfpenny Green as part of a display in the 1970s. The Skydiving Club at the Green used a Rapide for many years, and famously, on 15 July 1972, Mike Boulton from Wordsley was one of fifteen skydivers jumping from two aircraft. He jumped from an Islander and crashed through the roof of Rapide, G-AHAG flying beneath – one of very few people to take off in one aircraft and land in another.

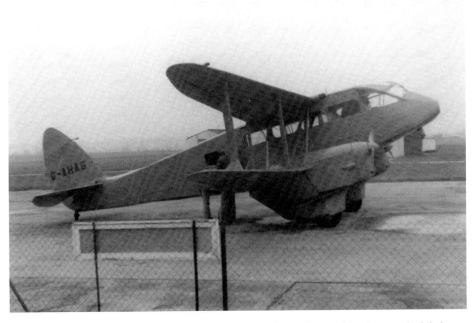

The Rapide G-AHAG, in April 1974, after the hole in the roof, caused by the un-scheduled entry of Mike Boulton, had been fully repaired.

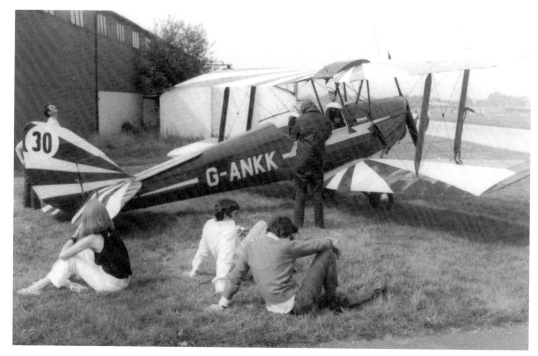

Tiger Moth G-ANKK, based at Halfpenny Green for some time, and now based not too far away at Baxterley, near Atherstone, having had this sunburst colour scheme replaced by an all-yellow RAF scheme.

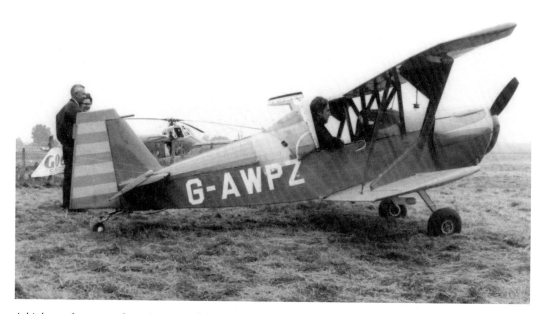

A biplane of more modern vintage at the green, the Andreasson BA.4B, G-AWPZ, now still based at Halfpenny Green, and also now all-yellow. It took part in many Halfpenny Green air shows at the hands of Peter Phillips.

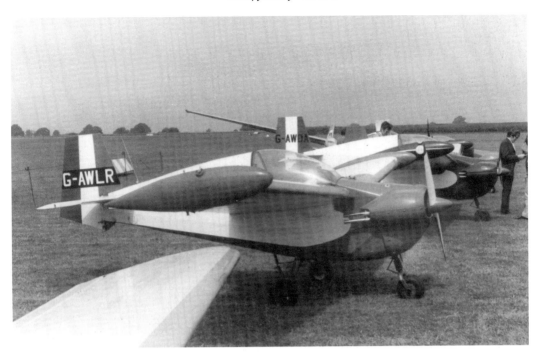

A Tipsy Nipper gathering at Halfpenny Green in the 1970s, with G-AWLR in the foreground and G-AWDA behind.

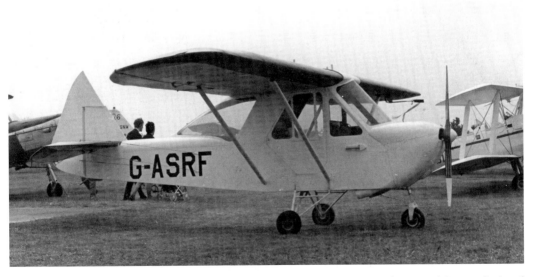

The unique Gowland Jenny Wren, G-ASRF, at a PFA fly-in at the green. This aircraft is now displayed in the Norfolk and Suffolk Aircraft Museum at Flixton.

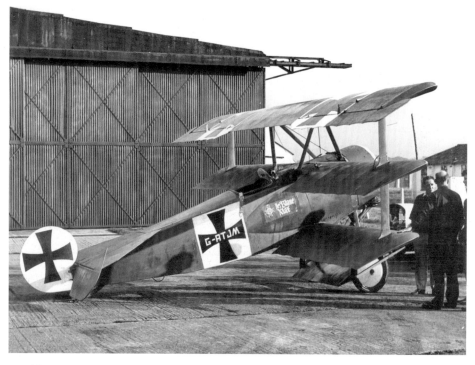

A Fokker DR.1 replica, G-ATJM, which had been built for the Twentieth Century Fox film, *The Blue Max*, and named here after the film. The aircraft is shown on a visit to Halfpenny Green.

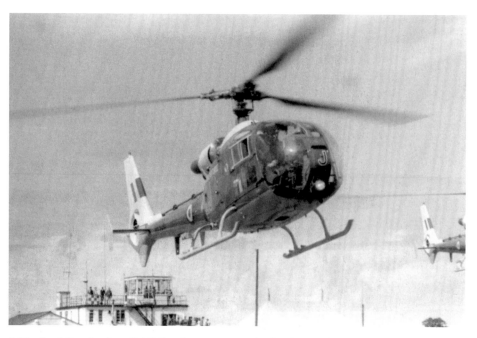

A Westland Gazelle, from RAF Shawbury at an air display during the 1970s, with Halfpenny Green tower just behind.

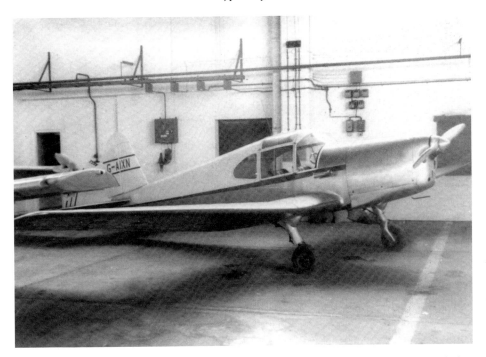

An unusual resident at Halfpenny Green for a while was this very rare Mraz M.1C Sokol, G-AIXN, built in Czechoslovakia.

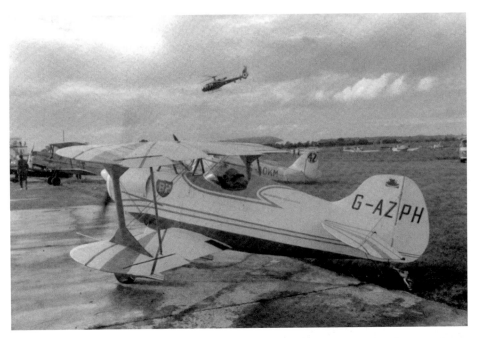

The Pitts Special G-AZPH, formerly owned by the great aerobatic pilot, Neil Williams, and now part of the Science Museum Collection in London, shown here at a Halfpenny Green air show.

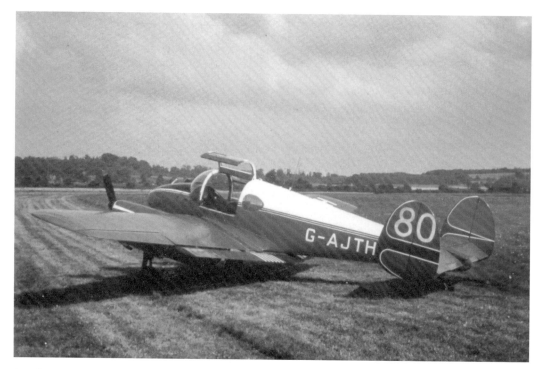

A Miles Gemini, G-AJTH, built in 1947, at Halfpenny Green to take part in the 1966 Goodyear air trophy race.

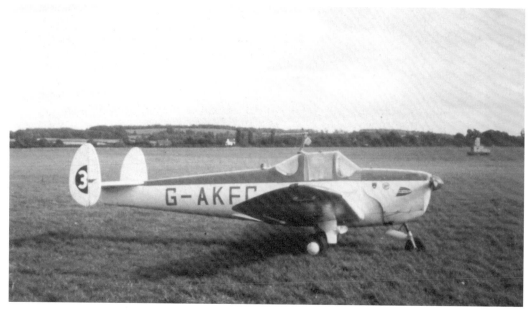

The unusual Ercoupe 415, G-AKFC, which crashed while undertaking practice emergency landings on 13 August 1967, hitting a tree and just missing a bungalow not far from the site of the Cosmic Wind crash the year before. Pilot Norman Brook only suffered cuts and bruises.

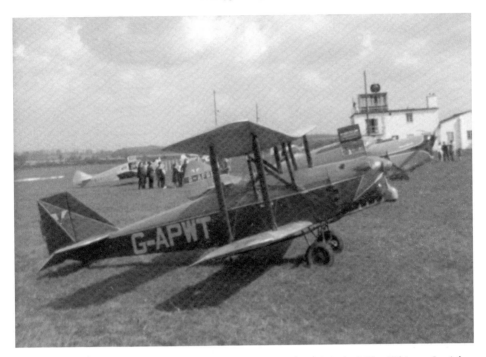

The Currie Wot, G-APWT, at a fly-in during the 1960s. Behind it is the Miles Whitney Straight, G-AFGK, and the Miles Falcon G-AEEG.

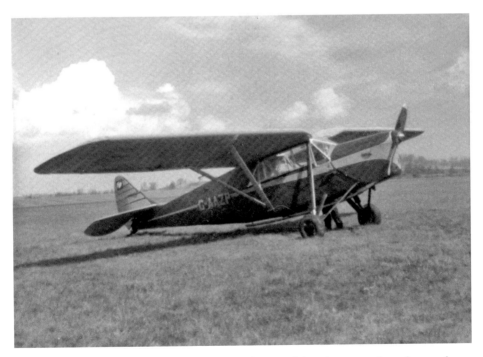

At the same fly-in was the Puss Moth G-AAZP. The aircraft has since gone through a number of colour schemes and is now in an original sky-blue scheme.

Left: One of the Tipper Air Transport Avro C.19 Ansons fruitlessly awaiting a buyer. Unusually this one does not have its civil registration crudely painted on, as most of the others did.

Below: A visiting Auster in unusual Canadian markings, and an increasingly rare Thruxton Jackeroo, from Baxterley in Warwickshire, at the Easter Charity Wings & Wheels Fly-in in 2009.

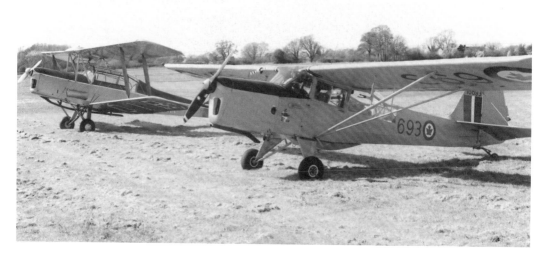

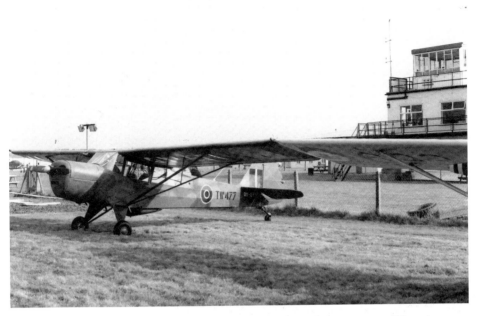

A Danish-owned Auster V in front of the control tower also at the 2009 Easter Wings &
Wheels Fly-in, which featured several members of the Auster Club.

Air Scout, Doug Robinson, sampling the cockpit of Roy Targonski's Jurca Tempete, normally
hangared at Halfpenny Green.

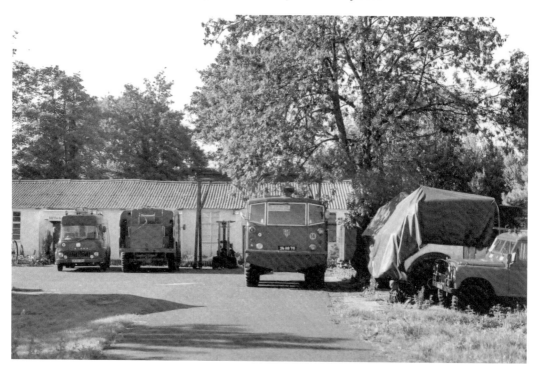

For just one year the RAF Fire Service Museum was at Halfpenny Green, housed in the building behind, with a marvellous collection of ten fire engines on display outside.

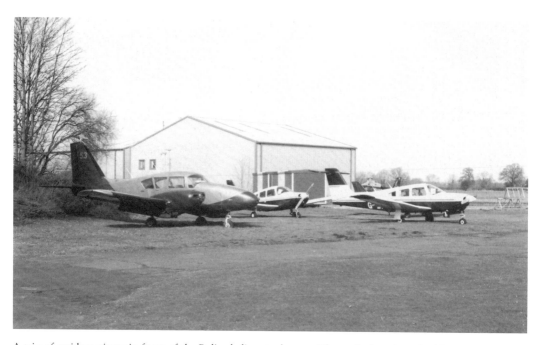

A trio of resident pipers in front of the Police helicopter hangar. The engineless Aztec had been grounded for a long time when this picture was taken early in 2009.

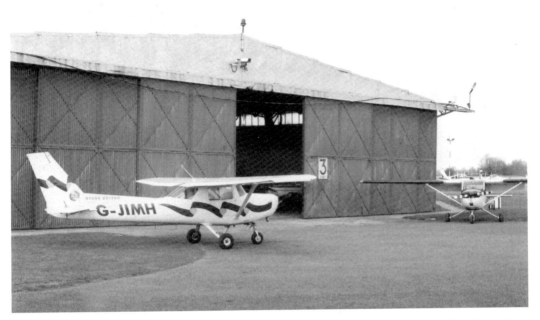

The Cessna F.152, G-JIMH, outside no. 3 hangar. Built in 1980 by Rheims Aviation, this aircraft had previously been registered G-SHAH.

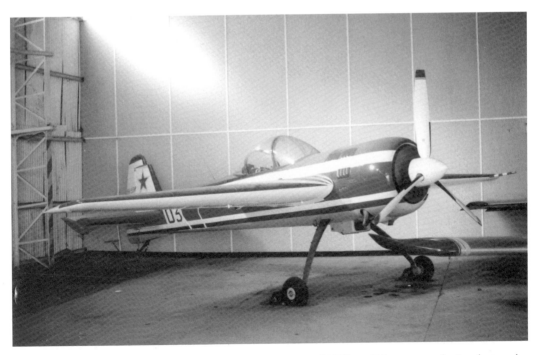

Now something of a 'hangar queen', the Russian registered YAK-55, RA-01274, gathering dust, and a reminder of Gennedy Effimov's Skytrace Aerobatic School, which was resident at the Halfpenny Green for a while from 1993.

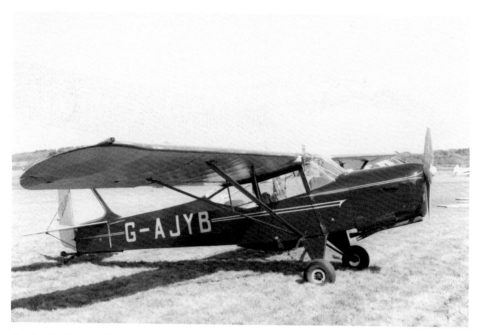

The lovely Auster Alpha, G-AJYB, parked in the sun on a visit to the Green in 2009, and a reminder that the first civil aircraft based at the green was Ted Gibson's Auster Alpha.

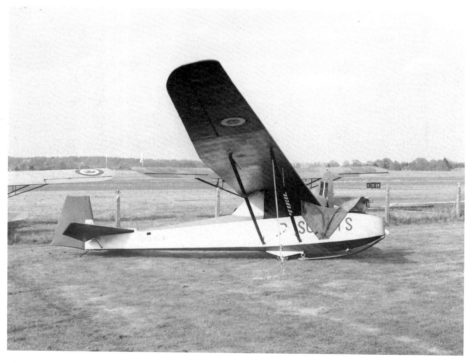

The Halfpenny Green Air Scouts' Slingsby T-31 glider, having a rare outing in the fresh air, displayed in front of the control tower, just before the Easter Fly-in 2009.

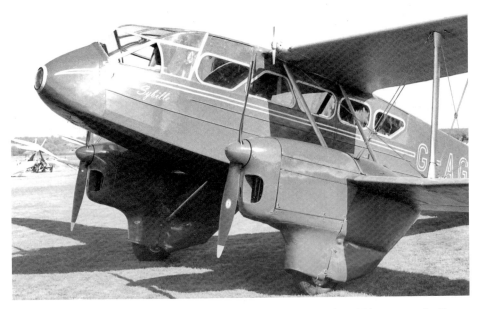

Air Atlantique's Dragon Rapide G-AGTM, awaiting passengers in the midday sun, at the Easter Fly-in in 2009.

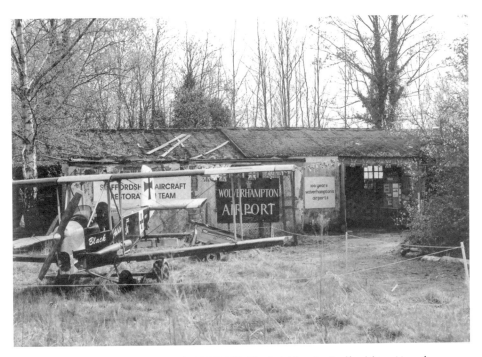

Fronted by the Microlight Tiger Cub, G-MMFS, *Black Adder,* the Staffordshire Aircraft Restoration Team's exhibition of *100 Years of Wolverhampton's Airfields* at the same fly-in.

Members of the Stourbridge Vintage Car Club leaving the Easter Wings & Wheels Display, 2009. When nearly new these cars may well have been driven to Alan Cobham's Flying Circus in 1935 at Perton. Three years later they may have taken their owners to the official opening of Wolverhampton Municipal Airport at Pendeford.